A Guide to Historic
Nashville
T E N N E S S E E

A Guide to Historic Nashville

TENNESSEE

James A. Hoobler

Published by The History Press
Charleston, SC 29403
www.historypress.net

Copyright © 2008 by James A. Hoobler
All rights reserved

Cover design by Marshall Hudson.
All images courtesy of the author unless otherwise noted.
Maps by Ryan Sherby.

First published 2008

Manufactured in the United Kingdom

ISBN 978.1.59629.404.2

Library of Congress Cataloging-in-Publication Data

Hoobler, James A.
A guide to historic Nashville, Tennessee / James A. Hoobler.
p. cm.
Includes bibliographical references.
ISBN 978-1-59629-404-2
1. Historic sites--Tennessee--Nashville--Guidebooks. 2. Historic buildings--Tennessee--Nashville--Guidebooks. 3. Nashville (Tenn.)--Tours. 4. Nashville (Tenn.)--Buildings, structures, etc.--Guidebooks. 5. Nashville (Tenn.)--History. 6. Walking--Tennessee--Nashville--Guidebooks. 7. Automobile travel--Tennessee--Nashville--Guidebooks. I. Title.
F444.N243H66 2008
917.68'550454--dc22
 2008003140

Notice: The information in this book is true and complete to the best of our knowledge. It is offered without guarantee on the part of the author or The History Press. The author and The History Press disclaim all liability in connection with the use of this book.

All rights reserved. No part of this book may be reproduced or transmitted in any form whatsoever without prior written permission from the publisher except in the case of brief quotations embodied in critical articles and reviews.

Contents

Preface		7
Introduction and Early Homes		17

Downtown Nashville Walking Tours

Tour One	The Riverfront and Second Avenue	33
Tour Two	Lower Broadway	45
Tour Three	Upper Broadway	59
Tour Four	Church Street	69
Tour Five	Fourth, Fifth and Sixth Avenues	81
Tour Six	Tennessee Government	89

Nashville Driving Tours

Tour Seven	Music Row and Music City	103
Tour Eight	The Battle of Nashville	113
Tour Nine	Historic Neighborhoods	129
Tour Ten	Historic University Campuses	141
Tour Eleven	Historic Cemeteries	151

Reading List	167

Preface

The battle for preservation is a daily struggle. Every time we let our guard down, someone will try to strip the fabric of our past from us. That leaves us with a void that hardly allows us to recognize where we are, and how our cities came to be what they now are. The past created us, and we need to have tangible pieces of it with us to know who we are. This book tells us where Nashville is now by showing us where we have come from to get here.

This guide is divided into six downtown walking tours, a Music Row tour, the Battle of Nashville driving tour, selected properties in historic neighborhoods, three historic campuses and two historic cemeteries. This is meant to be a compact guide to visitors, newcomers and longtime residents of Nashville alike. Use it to explore the city and to deepen your understanding of the diverse history that made the city of today.

In the 1970s, Nashville debated tearing down the Ryman Auditorium and using some of its bricks to erect a chapel at the new Opryland Amusement Park. Fortunately, that was not done. At Third and Gay Streets stood a building that had been used by Standard Candies for years to store Goo Goo Candy Clusters. It had been the Second Presbyterian Church, built in 1846, and designed by notable architect William Strickland. In 1979, it was demolished for about twelve parking spaces. Shortly thereafter we lost 180 acres of the Battle of Nashville Battlefield to the Burton Hills development, and the Compton house that had been used by both armies as a field hospital was torn down. The National Life and Accident Insurance Company tore down their building on Seventh Avenue, which had been the first home to the broadcast of the Grand Ole Opry. The Tennessee Historical Commission moved into the antebellum home Clover Bottom, and the state nailed sheetrock over the decoratively painted

ceiling in the double parlor. The rail barn at Union Station, which made the site a National Landmark, was demolished by its owner. Union Station is no longer a National Landmark. The antebellum State Insane Asylum was demolished, as were an 1868 Nashville & Decatur rail barn, the Hugh Thompson–designed Glen Leven Presbyterian Church and Evergreen, the circa 1795 home of pioneer preacher Thomas Craighead.

At the same time as all of these losses, we also managed to stop a developer from putting up a twelve-story office tower on Second Avenue. But this success was only achieved after that entire block "mysteriously" burned to the ground, after developers were told they could not level the nineteenth-century structures on the site. Union Station and the Hermitage Hotel were both saved. The Nashville Union Stockyard was converted into a restaurant, and the capitol and The Downtown Presbyterian Church were restored.

The city had rallied earlier and saved the Parthenon, an art exhibition space from the Tennessee Centennial Exposition of 1897, by rebuilding it in the 1920s. Cheekwood was converted into a botanical and arts center and was saved.

We have lost some incredible pieces of our history. But we have also rallied and fought to save others. This is a constant struggle, and we must never surrender to those who denigrate our past and seek to destroy it. Perhaps this book will kindle a passion for our past in someone who will carry the battle forward, and continue to preserve a presence for the past.

Following are several examples of historic buildings that are forever lost to us.

Second Presbyterian Church

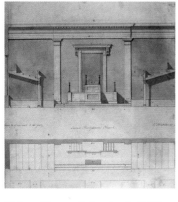

This architectural drawing by William Strickland, of Second Presbyterian Church, was drawn in 1846. *Courtesy of the Tennessee State Library and Archive.*

This architectural drawing by William Strickland, of Second Presbyterian Church, was drawn in 1846. The congregation worshiped here until shortly after 1900. The building was then sold and used as a warehouse by the Standard Candy Company for storing Goo Goo Candy Clusters. It was torn down by Metro in 1979, for about twelve parking spaces for the new Criminal Justice Center.

The Interior of the Second Presbyterian Church

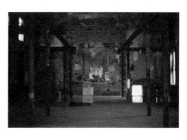

The interior of the Second Presbyterian Church as it appeared before it was destroyed in 1979.

In 1979, the interior of Second Presbyterian Church still had the frescoed wall at the front of the sanctuary, and the trompe l'oeil pilasters, ceiling decoration, window sashes and flooring. The studs could be seen in the wall surrounding the fresco corresponding to the door frame behind the lectern in the drawing by Strickland. The fresco was a view from the doorway to a classical-style porch, with columns in front, a coffered ceiling painted between the doorway and the columns and a landscape of hills with a rising or setting sun half visible in the distance of the painted view. The walls had trompe l'oeil pilasters painted on them and the ceiling had trompe l'oeil coffering painted on it. There was a balcony at the rear of the sanctuary and a framework that had supported side galleries. The window sashes, wainscoting, front doors and flooring were all still in the building. The Tennessee Historical Society director and the Tennessee State Museum asked to be allowed to salvage elements before the building was destroyed, but they were refused. It was razed in 1979.

The Felix Compton House

The Felix Compton house was built in 1844 and was used by both sides as a hospital during the Battle of Nashville, December 15–16, 1864. Built in part in 1811 by John Lucas, the house had heavy timber walls covered with weatherboarding. In 1822 the Lucases moved to Hardin County. Then John Boyd purchased the house and 100 acres. Felix Compton purchased it in 1858, and by 1860 he owned 750 acres, with 500 acres of it in fields and pastures. He worked the land with thirty-seven slaves. After the war the farm was expanded to nearly 1,000 acres, and the family continued to live there until 1905. In 1929, A.M. Burton bought the property and lived in it until 1984. At his death it went to David Lipscomb College, with 180 acres left for intensive development. The house was cut up and removed.

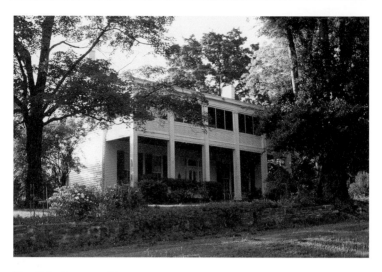

The Felix Compton House.

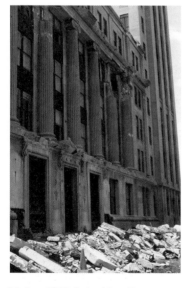

National Life & Accident Insurance Company Building during demolition.

National Life & Accident Insurance Company Building

This building was the National Life & Accident Insurance Company's home from 1924 until 1969. This was where the Grand Ole Opry was first broadcast in 1925, and it continued to be the home of WSM and the Opry until 1934. That company had it demolished in the 1980s for a planned twin tower to their 1969 and 1970 Skidmore, Owings & Merrill travertine corporate tower. A parking lot was put in temporarily, and that lot is still there at Seventh Avenue and Union Street.

Clover Bottom Mansion

The decoratively painted ceiling in Clover Bottom dates to about 1860, when the house was new. James and Mary Ann Hoggatt lived there with about sixty slaves. Dr. James Hoggatt died in 1863

after a long illness. In the early 1880s the property was sold to Andrew Price of Louisiana. It was not a primary residence again until 1918, when A.F. Sanford purchased the house. He and his family lived there until 1946, when the state acquired it as a new location for the Tennessee School for the Blind. Staff then lived in the house. It is now the office of the Tennessee Historical Commission. Unfortunately, the ceiling is covered with sheetrock.

Clover Bottom Mansion.

UNION STATION'S RAIL BARN

The Union Station rail barn resembled Gare St. Lazare in Paris, which was often painted by Monet. It was the largest clear span truss of its type ever engineered. On the roofline nearest to the station, there were vertical frosted-glass windows, with stained-glass roundels at the top of each band of frosted glass. The enormous span and the exposed iron trusses were a very imposing sight. Henry Sender leveled it for a surface parking lot.

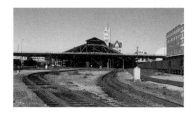

Union Station's Rail Barn.

THE TENNESSEE INSANE ASYLUM

Adolphus Heiman's Tennessee Insane Asylum was built from 1849 to 1857. When it opened, this was a humane experiment in the treatment of mentally

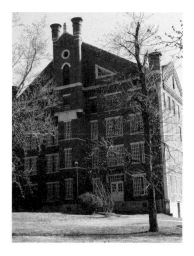

The Tennessee Insane Asylum.

ill people. There were rooms for the patients, a greenhouse for tropical plants and extensive gardens and ponds for the residents to enjoy in the fresh air. Dr. William Archer Cheatham, Adelicia Acklen's third husband, was the director here prior to the Civil War. Most of the building burned down, but this section was demolished for a Dell Computer building.

The Nashville & Decatur Rail Barn

The Nashville and Decatur Rail Barn.

The Nashville & Decatur rail barn, built in 1868, stood on Fourth Avenue South, beside City Cemetery. It was used as a cotton processing plant for many years after the railroad was taken over by the Louisville & Nashville Railroad. It was demolished sometime in the 2000s.

Glen Leven Presbyterian Church

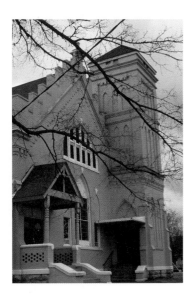

Glen Leven Presbyterian Church was built in 1891.

Glen Leven Presbyterian Church was designed by Hugh Thompson in 1891. Thompson was the architect of the Ryman Auditorium, First Baptist Church and several homes in the area. This building was sold by its congregation in the 1950s, and an African American congregation then bought it. The new group put in dropped ceilings, hiding the beamed ceiling, and put modern windows in place of some of those that had been removed by the original congregation when they left. The church was torn down to make room for rows of modern townhouses.

Evergreen

Evergreen, the home of Reverend Thomas Craighead, was built around 1795. It was a log house that was expanded and remodeled around 1837. Craighead was a pioneering preacher on the Cumberland frontier, having first visited here in 1785. James Robertson asked him to stay and preach to the settlement. He agreed to do so in return for land and a guarantee of $150 per year for three years. Subscriptions were taken up to pay him, and he received 640 acres of land. The Spring Hill Meeting House was erected for him about one mile south of Haysborough, where he lived in the station for protection from Indian raids. The Davidson Academy was chartered by North Carolina in 1785, and Craighead began teaching its classes in the Spring Hill Meeting House the next year. He was to be paid £4 per year for teaching each student.

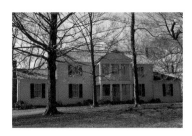

Evergreen.

With the coming of the Great Awakening around 1800, Craighead preached at many of the camp meetings that were a part of it. He did not adhere to the extremes of barking like a dog, fainting and speaking in tongues, but most of his church members took part in these new manifestations of "true" religion, and he soon found himself without most of his followers. He also got into trouble for his lack of belief in the doctrine of original sin. He was censured by the Presbyterian Church in 1810. But he continued to teach, even when Davidson Academy moved into Nashville. He then started Spring Hill Academy at the meetinghouse. In 1824, he got his censure overturned, and he died a few months later. The house was acquired by the George Bradford family, who owned it until 1980, when the widow of the singer Jim Reeves bought it to use as the Jim Reeves Museum. It sat empty for a number of years following the museum's closing and was eventually torn down to make room for a Home Depot.

The Nashville Parthenon

A facsimile of the Parthenon was built for the Tennessee Centennial Exposition in 1897, and the structure was rebuilt in the 1920s when the temporary exposition building had begun to deteriorate. It is one of Nashville's iconic symbols and

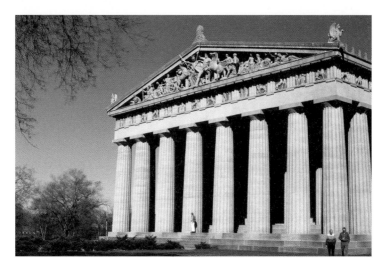

The Nashville Parthenon.

is an outgrowth of the city's self-designation as the Athens of the South. For the Centennial Exposition it served as the Art Building, A painting by Monet was among the works exhibited there. The city so loved this building that they insisted upon saving it. It was restored again in the 1990s.

CHEEKWOOD

Cheekwood.

Cheekwood was built in 1929 and was made into a botanical garden and art center in 1969. Its name comes from the combination of the last names of the owners, Mr. Leslie Cheek and his wife Mabel Wood Cheek. It was designed by the New York architect Bryant Fleming, who also laid out the extensive gardens. One of the features of Fleming's work was the reuse of details from British estates. The front wrought-iron gates are eighteenth-century English, the doors in the main hall are from the Duke of Westminster's home, the crystal chandeliers in the drawing room were the Countess of Scarborough's and the railing to the bedroom floor was from Queen Charlotte's house at Kew. There is a swan fountain on the front lawn that is supplied by a spring near the property

on Highway 100, and the water then comes out in an artificial stream that is channeled through a series of rivulets, ponds and cascades.

Nashville Union Stock Yard

Nashville Union Stock Yard was built in 1924 as a place to sell live cattle and fresh meat. Over the front door are carved limestone heads of a cow, pig and sheep. When the stockyard closed, the pens were pulled down and the building became a restaurant.

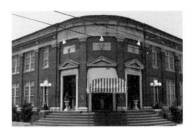

The Nashville Union Stock Yard.

Charles Warterfield Reliquary

Charles Warterfield served as a fresh new architect just out of Yale University in the late 1950s when the Tennessee State Capitol building was being renovated. He photographed that process and grew to love the building. When it was being restored in the 1980s, he watched with interest as that went on, and in the lead up to the State

Charles Warterfield Reliquary.

Bicentennial in 1996, he worked on the grounds of the building and did some of that restoration work. He directed as parts of the original Tennessee State Capitol columns were placed in a created architectural ruin on Capitol Hill in 1995. When he died shortly after this construction, the area was designated the Charles Warterfield Reliquary.

Introduction and Early Homes

The Cumberland country was a rich alluvial plain at its heart. The Cumberland River writhed through the bottom of the geological bowl, now called the Nashville Basin, like an anaconda. Along its banks were mineral springs, which attracted buffalo, elk, deer and bear. This in turn had attracted Native American peoples for several thousand years. But by the time of the late eighteenth century, the country was depopulated. The Cherokee to the east, the Shawnee to the north, the Chickasaw and Choctaw to the west and the Creek to the south had agreed to cease their fighting over what they called "The Dark and Bloody Ground." Instead, they would share it as a common hunting ground. The Great Salt Lick would continue to attract game, but without a settlement by native peoples it also attracted French fur trappers, and then British long hunters from across the Appalachians.

On Christmas Day, 1779, James Robertson led a group of men across the frozen Cumberland River and then up the bluff on the southern side. There they determined to plant a settlement in the Cumberland country and to name it for Francis Nash, a North Carolinian who had died at the battle of Germantown, Pennsylvania, in 1777.

When they arrived here, there was already another European settler living at the Bluff, Timothy Demonbreun, a Frenchman from Quebec. He had been trapping here since about 1769, and was living at one point in a cave on the banks of the river. Demonbreun lived long enough to welcome the Marquis de Lafayette to Nashville in 1825.

Like Demonbreun, not all of the early settlers were Scots-Irish, though most were. Frederick Stump and Casper Mansker were two German pioneers who settled here. Stump's home and a recreation of Mansker's Station can be seen today. These earliest settlers lived in log houses, which could be double

cribbed dog-trots like Dunham's Station or two-story structures like Frederick Stump's home. Soon, however brick, and stone houses were being built, as the settlers felt more secure in their new home. The Bowen-Campbell house, Devon Farm and the McCampbell home are all from before 1800. With the dawn of the nineteenth century and increasing security, architecture took on grander forms. Woodlawn is a very early example of this, as was Rose Hill, the Rutledge house on College Hill. Greek Revival followed these examples of Federal-style architecture. Belle Air, which looks like the Hermitage did just prior to the fire of 1834, is an early example, and the Hermitage with its remodeled portico is one of our grandest homes in this style.

As the settlements grew and trade increased, merchants set up their shops, taverns opened, inns were built and a town began to take shape. Lardner Clark opened a shop on Market Street, today's Second Avenue, and sold piece goods, needles and pins beginning in 1786. The top of the hill was set aside as the location for the Davidson County Courthouse, and this location has remained the same since the eighteenth century. Nashborough was recognized by North Carolina as a settlement in April 1784. In 1790, North Carolina ceded what would become Tennessee to the federal government as a territory. Finally, in 1796, George Washington signed the Act of Admission, making Tennessee the last state admitted to the Union in the eighteenth century. On September 11, 1806, the new Tennessee General Assembly granted Nashville incorporation as a city.

Demonbreun's Cave

Demonbreun's Cave.

Demonbreun's Cave has two entrances. One is on the top of the bluff and the other is visible from the river. He is believed to have lived here the first year of his settlement on the Cumberland. His name has been Anglicized from Jacques-Timothe De Montbrun, or James Timothy of the Brown Mountain. He had come here, leaving a family in French Canada, and settled along the Cumberland to trap furs. Born in Boucherville, Quebec, in 1747, he was living here as early as 1769. When the

Robertson and Donelson parties arrived here in 1779 and 1780, he was here to greet them. He remained until 1783, when he moved to the Illinois Country as a part of the George Rogers Clark expedition, and served there as the lieutenant governor until 1786. He resigned his military commission in 1786 and returned to Nashville in 1790, where he stayed the rest of his life.

In 1784, a year after Demonbreun had moved away, the North Carolina Legislature gave the settlement an official name. As the United States won its independence from Britain, they dropped the English village ending for a place name—borough—and used the term of our new ally, France. So the city became Nashville.

In 1797, the three sons of the Duc d'Orleans visited Nashville. The future King Louis-Philippe met Demonbreun, who was quite excited to have other Frenchmen to talk with. In 1825, the Marquis de Lafayette visited Nashville in order to meet America's icon, second only to George Washington in the number of images made of him during his lifetime: General Andrew Jackson. There was a ball given to honor George Washington's aide and Demonbreun was introduced to Lafayette.

Demonbreun and his French Canadian family lived in Kaskaskia, Illinois, and he had a Native American common-law wife and children as well in Nashville. He ran a store on the Public Square in Nashville and sold such items as window glass, paper, cured deer hides and buffalo tongues. His home stood at Third and Broadway. He died in 1826. A statue of him was erected in 1996 on the river bluff, near the simulation of Fort Nashborough. Alan LeQuire was the sculptor.

Frederick Stump Tavern, 4949 Buena Vista Pike

The Frederick Stump Tavern dates to around 1785. It is a two-story, double crib house with central hall and a rear "L," or wing. It is probably the oldest surviving house in Davidson County. Frederick Stump was born in 1723 in eastern Pennsylvania. He was an Indian fighter, and after killing a whole party of Indians and being jailed for it, he was freed from prison by other frontiersmen and fled with his family to Georgia. He fought in the Revolutionary War alongside Francis Marion. In 1779, he was captured and imprisoned by the British in Florida, but he bribed his jailer and returned to Georgia. There he found a reward on his head, so he moved to the Cumberland Country. He settled north of the river, on White's Creek, on Christmas 1779. In 1782 he built a gristmill, and shortly after that two log houses. The larger of the two he used as an inn. Living to the age of ninety-seven, in 1822, he was one of the wealthiest men

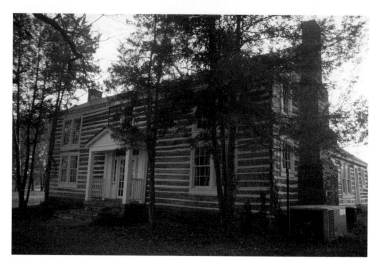

Frederick Stump Tavern, 4949 Buena Vista Pike.

in the area. The inn has been a residence since about 1846.

Dunham Cabin, 5025 Harding Pike

The Dunham and Harding Cabin at Belle Meade Mansion is a double crib log cabin. Half of it might date to around 1784. One of the last Indian raids on the settlements took place here in 1792. Daniel and John Dunham had settled on the banks of Richland Creek in 1784, and built a log fortification known as Dunham's Station. Daniel and two of his sons were killed in an Indian raid in 1787 on Richland Creek. John Dunham was killed in 1790. In 1792, John's widow, Sarah, was working in the cabin and heard her children scream outside. Rushing out the door, she saw her children being chased by several Indians. One of her daughters was captured, and Sarah charged at the Indian with a hoe and freed her daughter. She and the children ran back to the cabin and tried to close the door, but an Indian had thrust his rifle barrel inside. Sarah, thinking quickly, shouted out for a gun to be handed to her. The bluff worked and the Indians ran away. Part of the Station was burned in another Indian raid in 1792.

The Dunhams lived in their cabin until 1807, when they sold it to John Harding. A second log cabin was built near the Dunham cabin, and the two were joined by a common roof. This is known as a dogtrot cabin. The common open area between the two cabins was a cool place to work from in warm weather, and of course dogs would find it to be a comfortable

Introduction and Early Homes

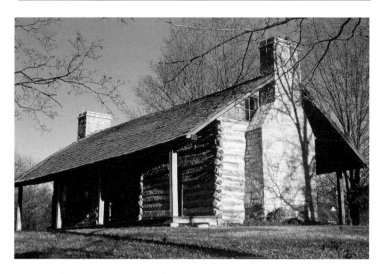

Dunham Cabin, 5025 Harding Pike.

place to sleep as well. William Giles Harding, the son of John and Susannah Shute Harding, was born here in 1808. By 1820, John owned over one thousand acres and forty-nine slaves, and they built a larger brick house a bit farther back from the road. About this time they acquired a three-year-old slave child named Robert Green. He eventually came to live in the cabins, and was known as Uncle Bob Green. He was the head groom for the farm, and helped to manage the thoroughbred horse stock. During the Civil War, he remained on what was then known as Belle Meade Plantation, and was shot by a Union soldier. He recovered and spent the rest of his life there, finally dying in 1906. He had married when he was nearing fifty years old, and he fathered eight children.

Mansker's Station, Moss-Wright Park, Goodlettsville

Mansker's Station is in Moss-Wright Park in Goodlettsville, and is a recreation of a 1780s frontier station, or fort, built to protect the settlers in the surrounding area. If Indians attacked, the settlers would gather at the fort for protection. This park facility holds a Colonial Fair in May and is a living history site, with

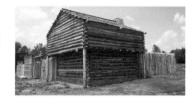

Mansker's Station, Moss-Wright Park, Goodlettsville.

costumed interpreters and an orientation film in the Bowen-Campbell House. Kasper Mansker had built his blockhouse and station near here in the 1780s. Mansker signed the Cumberland Compact, the ordinance for self-governance drafted in 1780. In 1790, Andrew Jackson and John Overton moved into Mansker's Station, having left the widow Donelson's house when her daughter Rachel was seeking to divorce her husband, Lewis Robards. They remained there until Jackson took Rachel to Natchez, Mississippi, in 1791 to marry him. In 1795, Mansker led an expedition to aid the settlers' friends, the Chickasaw, led by their chief, Piomingo, against a Creek Indian attack. He took a small cannon along, which helped to drive the Creeks away from Logtown, the Chickasaw settlement. André Michaux, the French botanist, also stayed at Mansker's Station in 1795. At about age sixty-five he volunteered to go to New Orleans with John Coffee's regiment to help fight at the Battle of New Orleans. In 1821, Kasper Mansker died.

BOWEN-CAMPBELL HOUSE, MOSS-WRIGHT PARK, GOODLETTSVILLE

The Bowen-Campbell House was built from 1787 to 1788. It is a very early example of Federal-style architecture built on the frontier, after the threat of Indian attacks had ended. Captain William Bowen settled in the area in 1784. This is the oldest brick house in middle Tennessee. In 1995, archaeologists found the original brick kiln. Captain Bowen fought in Lord Dunmore's War, the French and Indian War and the Revolutionary War. His grandson, Brigadier General William Bowen Campbell, was born in the house in 1807. He fought in the Seminole War, Mexican War and Civil War. He served as a U.S. congressman from 1837 to 1843 and as governor from 1851 to 1853.

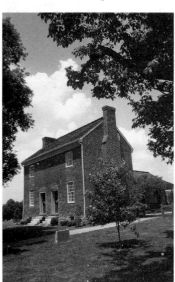

Bowen-Campbell House, Moss-Wright Park, Goodlettsville.

Devon Farm, or Oak Hill, 7401 Highway 100

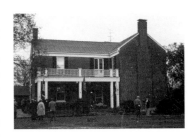

Devon Farm, or Oak Hill, dates to around 1798 and now is on the campus of Ensworth High School. It was built by Giles Harding, whose sons helped him to clear the land and build the house. In 1806, his son John bought the Dunham cabin and moved there. Giles died in 1810, and his second wife remained in the house. In 1816, David Morris Harding and his brother Thomas inherited the farm when David came of age. Morris Harding died in 1854. Fanny, Giles's second wife, stayed on until her death in 1865. Her nephew, Edward Dickson Hicks II, inherited the farm, and five generations of his family lived there until it was acquired by Ensworth School.

Devon Farm or Oak Hill, 7401 Highway 100.

McCampbell House, 305 Kent Road

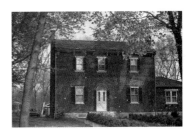

The McCampbell house was built around 1800. William Hall built this house and lived in it until Thomas Harding purchased it in 1820. In 1847, it was sold to James Anderson from Kentucky. In 1852, he sold it to Thomas McCampbell, who in 1846 had married Anna Gowdey, the daughter of a local jeweler and silversmith. It remained in the family until 1946.

McCampbell House, 305 Kent Road.

Locust Hill, 834 Reeves Road

Locust Hill was built in 1805 and has the finest carved, gouged, painted and grained paneled wall in Middle Tennessee in its master bedroom. The house was built by Charles Hays, who had paid $2,500 for 380 acres on the east side of Mill Creek. His wife Anne died in 1831, and Charles continued to live in the house after he had given it to their youngest son, Blackman, in 1837. Blackman Hays was elected to the Tennessee Legislature

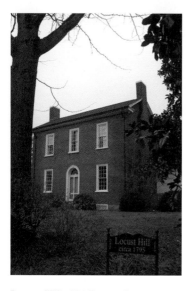

Locust Hill, 834 Reeves Road.

that year as a representative. Blackman married Minerva Gowen in 1825. She died in 1843, and Blackman died in 1847. The house then went to his dead brother John's son, Charles M. Hays. The elder Charles Hays was still living at that time, and may have still been in the house he had built. But by 1850 he moved away, and in 1854 he too died. The younger Charles M. Hays sold the house to his younger brother, James Hays, in 1857. James served in the Confederate cavalry under General Joseph Wheeler until he was captured and spent two years as a prisoner of war.

In 1870, the house was sold out of the family to Peter Rieves. Peter died in 1876, and his wife Celetie died in 1895. Their son Felix inherited it and lived in it until 1954. It remained in the family until 1965, when John Kiser bought and restored it. In 1986, he sold it to Raymond and Linda White. They sold it to Will and Trudy Byrd in 1992. They sold it to Chase Rynd, the first director of the Frist Center for the Visual Arts, in 1999. He sold it to Greg Estes in 2003.

ROSE HILL, 101 LEA AVENUE

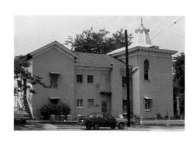

Rose Hill, 101 Lea Avenue.

Rose Hill was the home of Henry Middleton Rutledge and Septima Sexta Middleton Rutledge. They were first cousins and the children of Edward Rutledge and Arthur Middleton, South Carolina's signers of the Declaration of Independence. They had married on Septima's sixteenth birthday, October 15, 1799. In 1816, they and their five children moved to the frontier, on the Elk River in Franklin County, Tennessee. They made their home on a portion of Henry's father's Revolutionary War land grant of

73,000 acres. By 1820, they had also built Rose Hill, where they entertained such guests as Andrew and Rachel Jackson, James K. and Sarah Childress Polk and Sam Houston. Lafayette was entertained by them in 1825. Built in 1814, Rose Hill was similar to Septima's family home, Middleton Place, near Charleston, South Carolina. It had a large central two-story structure, with two-story connectors to flanking two-story pavilions. A fire at the end of the Civil War destroyed Rose Hill except for one of the wings. It stands at the rear of 101 Lea Avenue. Henry died in 1844, and Septima in 1865.

Woodlawn, 127 Woodmont Boulevard

Woodlawn was the home of Willoughby Williams and was built in 1822. It was an English Regency–style home, also reminiscent of Middleton Place near Charleston, South Carolina. In 1916, the eastern wing and pavilion were demolished when Woodmont Boulevard was built, and new columns were added to that end of the house. Hugh Roland was employed to design the new house. He also designed the Masonic Hall and Christ Church around that time. John Nichols had hired the architect, and when his daughter Nancy married Willoughby Williams, a successful local merchant, the house was transferred to them. Williams added the two wings to the house in order to accommodate his growing family. Williams served at one time as the president of the Bank of Tennessee. He eventually owned 1,800 acres on Richland Creek. By 1850, there were 111 slaves working the farm. By the 1850s, Willoughby Williams was spending more time on his property in Arkansas, and his son John Henry Williams came to live in the house with his wife, Elizabeth, their child and his youngest brother, Andrew. Andrew was killed during the war, and the house was ransacked during the skirmishing on the first day of the Battle of Nashville. John died in 1893, and the property was divided among his heirs. The house was sold out from the family in 1900, to Duncan Kenner. He sold it in 1916 to Henry B. Richardson. The Young and Moore families lived in it until the 1980s, when condominiums were built on the south lawn and the house became a business office.

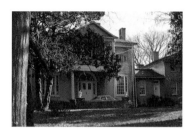

Woodlawn, 127 Woodmont Boulevard.

Belle Air, 2250 Lebanon Road

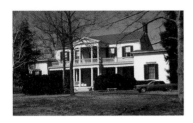

Belle Air, 2250 Lebanon Road.

Belle Air, built around 1827 and remodeled in 1838, was the home of banker William Nichol and his wife Julia Lytle. Resembling the Hermitage prior to the 1834 fire, it was built by Joseph and Elizabeth Clay. He sold the property to William Nichol in 1842 for $30,000, which included one thousand acres. William had been born in Abingdon, Virginia, in 1800. William Nichol was the first president of the Bank of Tennessee. In 1835, he was elected mayor of Nashville. The Nichols added the two wings to the sides of the house. By 1850, they owned 1,250 acres and seventy-three slaves. In 1861, the estate had grown to be worth $1 million, and included 1,800 acres. William had inherited property in the city from his father, and also had a farm in Arkansas. Following the war, the house was enlarged to thirty rooms with the addition of a rear wing. William died in 1878, and Julia, his wife, died in 1890. She had sold the house in 1881, prior to her death.

The Hermitage, 4580 Rachel's Lane

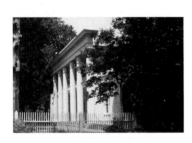

The Hermitage, 4580 Rachel's Lane.

The Hermitage, home of President Andrew Jackson, was originally built in 1819 and was remodeled after a fire in 1834. The Jacksons moved into a log blockhouse at the back of this property in 1804. In 1819, they began construction on a large two-story brick house, which they completed in 1821. The Jacksons raised cotton with the work of fifty slaves, which in time more than doubled. While Jackson was serving as president, the Hermitage caught fire from a spark from the chimney and was gutted to a shell. As Jackson's second term as president was nearing its end in 1836, Joseph Reiff and William Hume were finishing their rebuilding and expansion of the house. Jackson died in 1845, and his wife's nephew, their adopted son, inherited the farm. By 1850 it comprised one thousand

acres, and 137 slaves worked on it. Always a poor businessman, Andrew Jackson Jr. sold the house and five hundred acres to the State of Tennessee in 1856. He then moved to Mississippi. The house began to fall into disrepair. Shortly before the Civil War he was invited to return as caretaker, and did so. The Federal troops guarded the former president's home from being pillaged during the war. Tragically, in 1865 Andrew Jackson Jr. died in a hunting accident. His widow Sarah lived on at the Hermitage until her death in 1888.

The following year, the Ladies Hermitage Association was formed to manage the property and to restore and interpret it for the state. Andrew Jackson III had removed all of the furnishings and property from the house at that time. Over the years, the Ladies Hermitage Association has worked to return the house to its condition and appearance when President Jackson lived in it. They have largely succeeded in reacquiring those pieces over the years. The home is open for touring, as are Tulip Grove and the old Hermitage Presbyterian Church. The visitors' center has an interpretive film, museum, restaurant and shop.

THE TOMB OF ANDREW AND RACHEL JACKSON, 4580 RACHEL'S LANE

The tomb of Rachel and Andrew Jackson at the Hermitage was designed by David Morrison in 1831. Rachel was buried there in 1828, and Andrew in 1845. Uncle Alfred, a former slave of General Jackson's, is buried near the tomb in the family burial plot. He lived on at the Hermitage until 1901, giving tours of the house up to his end.

Another burial there is that of Ralph E.W. Earl. Earl was a portrait artist who married one of Rachel's family members. They moved into the Hermitage with the Jacksons. Earl was the founder of the first museum west of the Appalachian Mountains, Earl's Museum, located on the

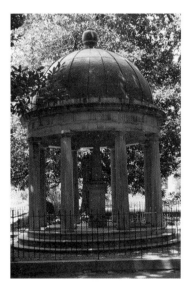

The tomb of Andrew and Rachel Jackson, 4580 Rachel's Lane.

Public Square in Nashville. He exhibited the painting that he brought with him to Nashville, a portrait of Napoleon, in that museum, as well as a life-sized portrait that he made depicting Jackson on the battlefield at New Orleans. The Napoleon portrait was probably the bait he used to lure Jackson into doing a sitting. That life-sized portrait was toured nationally by Earl, and he charged admission of people wishing to see it. Jackson, after the Battle of New Orleans, was seen by many as the second George Washington, having again defeated the British and ensured our continued existence as a country.

CLEVELAND HALL, 4041 OLD HICKORY BOULEVARD

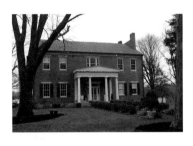

Cleveland Hall, 4041 Old Hickory Boulevard.

Cleveland Hall was the home of Rachel Jackson's nephew, Stockley Donelson, and was built in 1839. He used the Philadelphia architects Reiff and Hume, whom Andrew Jackson used to rebuild the Hermitage after it burned in 1834.

Donelson's grandfather, Colonel John Donelson, had led his family and thirty-five other flatboats on a river journey to the Great French Lick in 1779–80. They built the vessels at Fort Patrick Henry, on the Holston River. Their voyage turned into four months, one thousand miles and many narrow escapes. They had an outbreak of smallpox, were harassed by Indians and had to leap into the wilderness with their families, goods and their hopes and dreams for a successful future. Reaching the Tennessee River, they proceeded to Muscle Shoals and had hoped to be met by James Robertson and some others of the men who had struck out overland ahead of them. But the men did not arrive, so the party decided to float on down to the Ohio River and then pole their way up to the Cumberland and up it to the Great French Lick. Miraculously, they made it. When Theodore Roosevelt was writing his book, *The Winning of the West*, he referred to this as the "Great Leap Westward," and called it one of the most daring exploits in the settlement of North America. Donelson reunited families at the bluff, and then poled on up the river to where the Stones River joins the Cumberland. He made his land claims there.

Captain John Donelson, the son of Colonel John Donelson, was also a surveyor. Indian raids, a flood and several deaths from

disease convinced Colonel John to withdraw to the relative safety of Mansker's Station, which he did. Still not feeling safe, he and his family moved up to Kentucky. In 1785, they felt that things had become safe enough to return to their land claims. Colonel John had some business to take care of, and he left after his family had struck out for Nashville. He was ambushed and killed on the road down from Kentucky, presumably by Indians.

Around 1804, a large log house was erected on their land claim and was named the Mansion. Stockley, the twelfth and second to last child born to Mary and Captain John, was born in 1805. His aunt was Rachel Donelson Jackson, who lived only about one mile away at the Hermitage. Stockley became a lawyer and married Phil Ann Lawrence. They built the large two-story brick house near the Mansion. Phil Ann had fond memories of visits to Cleveland, Ohio, so she named their home Cleveland Hall. Captain John's widow had a room on the back hall, and her grandchildren spent a lot of time there with her. She told of her life as a young bride and of the voyage to the bluff on the flatboat *Adventure*. She died in 1848. On that night, the aurora borealis gave a display, and the slaves thought that it was for her soul going to heaven.

Colonel Donelson had brought about thirty slaves with him on the *Adventure* in 1779–80. One of them, named Summerset, lived until about 1850 and told stories about the voyage and of how he had saved Colonel Donelson from an Indian attack. Another slave was Guinea George, who said that he had been a cannibal in Africa. He spent his summers alone on an island in the Cumberland River, coming back at harvest time. He would sing songs in his native language as he harvested cotton. One of the slave cabins from Cleveland Hall is now at Belle Meade Plantation and is used to interpret slave life.

Phil Ann died in 1851, and Stockley died in 1888. Their son William lived on at the house until his death in 1895. The house is still owned by a Donelson descendant.

Downtown Nashville Walking Tours

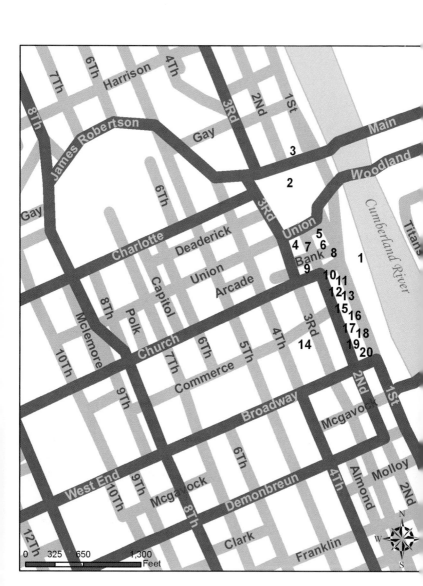

Tour One
The Riverfront and Second Avenue

The Cumberland River was Nashville's front door for most of the city's history. James Robertson walked across the frozen river to found the settlement in 1779, and a Davidson County Courthouse has always stood atop the bluff, where the present one is located today. Fort Nashborough was built along the river as a rectangle. Its narrow end was along the river bluff, where Church Street meets First Avenue, and the fort went up Church Street to just past Second Avenue. In the basement of 201–203 Second Avenue is the spring that watered Fort Nashborough.

The Market Street area was the business heart of Nashville for its first century, and even in the second and now third century of settlement, it continues as a center for business. The Cumberland River was the means to bring trade goods into the settlements of Middle Tennessee, and warehouses were built along the riverfront with large doors on the waterfront and shops on the next floor up, with large windows in which to display those things that were being sold on Market Street. The first steamboat to operate on the Cumberland was brought here in 1819 by General William Carroll, who had named it *General Jackson* in honor of his old friend.

Market Street developed into a thoroughfare with hardware merchants, saloons, whiskey distillery sales rooms, seed and feed stores, dry goods stores, lumber dealers and coffee blenders. Just about anything that could be sold was sold there in its nearly two centuries of wholesaling. Today it is a vibrant retail, restaurant, office, bar and dance hall location. In the 1970s, there was a preservation effort led by many people who wanted to preserve this street from being either torn down or so insensitively modified as to have destroyed its character. Fortunately they prevailed.

1. Fort Nashborough, Riverfront Park

Fort Nashborough, Riverfront Park.

Beginning our tour at the approximation of Fort Nashborough, along First Avenue, we can gain some sense of what life would have been like here, hundreds of miles away from any other frontier settlement, in the late eighteenth century. This simulation of the fort was built in 1930 by the Daughters of the American Revolution. It is open to the public. The original fort covered two acres and was lined on the outer edge with cabins and blockhouses at its corners. Judge Richard Henderson had contracted with the Cherokee Indians, at the Long Island of the Holston, to buy central Kentucky and upper Middle Tennessee. This deal was called the Transylvania Purchase and was the largest private land transaction in American history. Henderson needed good men with knowledge of the western areas to lead expeditions to settle his new acquisition. So he had Daniel Boone lead a group into Kentucky and James Robertson lead a group into Tennessee. The Tennessee group decided to have the men walk over land from Fort Patrick Henry to the Bluffs, and the women, children, old people and property would float on down to Muscle Shoals, reunite there with some of the men who had walked overland and then walk back to the Bluffs. The plans did not succeed as originally conceived, but the two parties did make it to the Bluffs. The settlement, after many Indian raids, finally made a success of it and grew into today's Nashville.

2. Davidson County Courthouse, Public Square

The Davidson County Courthouse originally occupied only the eastern third of the present building's site. Second Avenue, then known as Market Street, went right through where the doors are now to the present courthouse. The western third of the site had a farmer's market, and later a city hall on that site. The present building was designed in 1937 by F.R. Hirons and Emmons H. Woolwine. It is a combination of classicism and Art Deco, with murals in the lobby by nationally acclaimed artist Dean Cornwell. The murals depict an outline map of the city of Nashville as it existed in 1937 and an outline map of Davidson County. Superimposed over these maps are figures representing

The Riverfront and Second Avenue

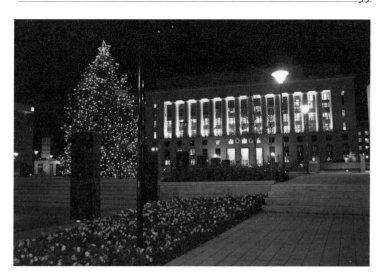

Davidson County Courthouse, Public Square.

Agriculture with a female figure and Industry with a male blacksmith. For Nashville, there is Commerce represented by a female figure and Statesmanship with a figure of Andrew Jackson. There are trompe l'oeil medallions depicting aspects of the city's history, such as Kasper Mansker, the Battle of Nashville and many others. The electric ceiling fixture has signs of the zodiac in etched glass panels surrounding it. Several of the courtrooms have Art Deco painting on the ceiling. On the frieze at the roofline are carved limestone heads of a cobra, a lion and a bull. They represent wisdom, courage and strength.

The Public Square was tripled in size and then converted into an underground parking garage with a surface-level public park in 2006. It has fountains, picnic tables and chairs and a tower with images from photographs of the square over the past century and a half laser cut onto stone display panels. There are maps showing how it has developed over the years. There are also images from ads for merchants who used to be located on the square. In 1862, the square saw an army of conquest and occupation muster in to take control of the first Southern state capital city to fall to the United States Army. The civil rights marches to desegregate public lunch counters in Nashville ended on the courthouse steps, with Fisk and Tennessee State University students asking the mayor to call for an end to segregation in 1960.

3. City Market, 408 Second Avenue North

City Market, 408 Second Avenue North.

The City Market moved into its own building in 1937, on the northeast side of the Public Square. The building was designed by Henry C. Hibbs, who had moved to Nashville in 1914 to supervise construction of the new George Peabody College for Teachers. The market is in one of his two preferred styles of architecture: that inspired by Rome and that inspired by the Middle Ages. This particular structure has a Roman dome and columns at the entrance. It had tile stalls in the hallways from which farmers would sell their produce. It was a traffic court for many years, and now holds offices. Henry Hibbs also designed the American Trust Building's upper floors, the Education Building on The Downtown Presbyterian Church, Scarritt College, Rhodes College, the Meharry Medical College Obstetric and Pediatric Building, the library at Fisk University and the Nashville Electric Service Building. He won the 1929 American Institute of Architects gold medal for his design at Scarritt. He also did design work for Davidson College and Mary Baldwin College.

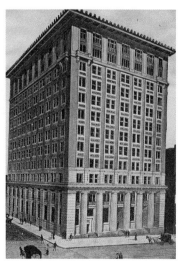

The Stahlman Building, Third Avenue North and Union Street.

4. The Stahlman Building, Third and Union Avenues

The Stahlman Building was the tallest building in Nashville when it was built in 1905–06, due to its location on a hill. It was designed by Otto Eggers of New York and J. Edwin Carpenter and Walter Dabney Blair, from here in Nashville. Carpenter was the first Tennessee-born architect to study at the École des Beaux-Arts in Paris. Unfortunately, the cornice was removed from the building.

Carpenter also designed the Hermitage Hotel, the Vanderbilt University Library, Maury County Courthouse and many luxury apartments on Park Avenue and Fifth Avenue in New York City. An Art Deco canopy was added to the Union Street entrance of the Stahlman Building in the 1930s. The building reopened in 2007 as an apartment building.

Second Avenue, looking south from the Square

Second Avenue (Market Street) developed along the riverfront, with a city wharf at its back, large doors to unload riverboat cargoes into the warehouse floors above and a front on Second Avenue, from which to sell the goods that the river traffic brought in. Wagons and then trucks loaded up on Second and distributed the goods to surrounding counties.

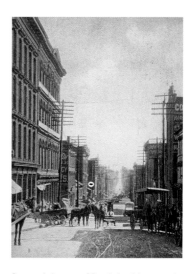

Second Avenue North looking south, around 1900.

5. Brandon Printing Company, 228 Second Avenue

The Brandon Printing Company was built in 1892. The architect was Julian G. Zwicker, who also designed One Hundred Oaks Castle in Winchester, Tennessee, and the Silver Dollar Saloon at Second and Broadway. In 1939, the Washington Manufacturing Company took over the building and continued to make DC jeans there until the 1980s. Notice the wonderful terra cotta on this building. A satyr head is on the capitals to the pilasters on the ground floor, and a dragon with open

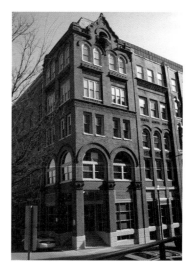

Brandon Printing Building, 228 Second Avenue North.

wings is holding up the balcony at the top. This dragon is seen in a larger size across the river at Tulip Street Methodist Church.

6. Morris & Stratton Building, 218–220 Second Avenue

Morris & Stratton occupied this site in 1854 for their wholesale grocers business. During the Civil War the building was used as a Federal hospital for sick and wounded Union soldiers. The old street number, 14, is in a U.S. Federal shield on the cast-iron columns flanking the old entrance. Unfortunately, a developer demolished the original building and only salvaged the façade.

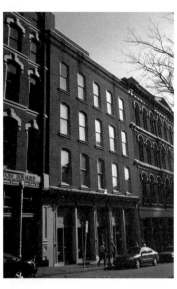

Morris & Stratton Building, 218–220 Second Avenue North.

7. Gray & Dudley Building, 225 Second Avenue

The Gray & Dudley Building was erected in 1900. They were hardware merchants, boasting twenty-five salesmen on the road that year. The building is the only structure on the west side of Second Avenue to have imposing façades on both Second and Third Avenues.

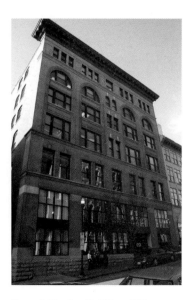

Gray & Dudley Building, 225 Second Avenue North.

8. Washington Manufacturing Company, 214–216 Second Avenue

In 1786, Lardner Clark arrived from Philadelphia with ten horses loaded with piece goods, needles and pins. He opened a dry goods store approximately on this site. The current building dates to about the 1870s. By 1881, the Morris and Stratton families owned this entire block. In 1939, Washington Manufacturing became the owner of the block. They made DC jeans and casual clothing. The building now houses various businesses. There is a light atrium on the Bank Street side of the building that was added when the property was remodeled in the 1980s.

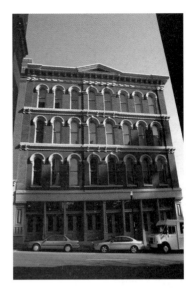

Washington Manufacturing Company, 214–216 Second Avenue North.

9. George Dickel Co. and Roberts Candy Building, 201–203 Second Avenue

The west side of Second Avenue had the façades removed from Broadway to Church Street in 1934 in order to allow the new freight trucks, which had replaced wagons, to maneuver on the street. As early as 1869 George A. Dickel Co. rented property at 201–203 Second Avenue North. This building was built by them in 1882. In 1917, the property was sold and the Roberts Candy Company purchased the site. It now has offices on the second and third floors, and a shop at street level.

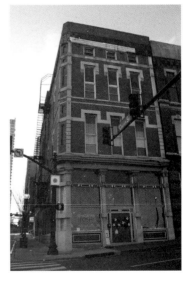

George Dickel and Co. and Roberts Candy Building, 201–203 Second Avenue North.

10. C.T. Cheek & Son, 184 Second Avenue

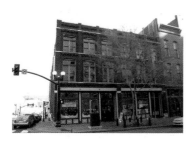

C.T. Cheek & Son, 184 Second Avenue North.

Erected in 1898 and occupied by C.T. Cheek & Son in 1901, this structure was where Leslie Cheek, the son and partner in the firm, began work in the wholesale grocery business. He later sold his Maxwell House Coffee stock to General Foods and invested in a new start-up company—IBM. With his new wealth, he built an estate for his family, which they named Cheekwood. His wife's maiden name was Wood, so he put both names together for the name of their new home.

11. Rhea Building, 164–168 Second Avenue

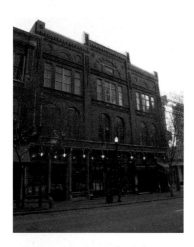

Rhea Building, 164–168 Second Avenue North.

The Rhea Building was erected in 1887 by Bird S. Rhea for a seed and feed business. By 1895, the Buford Brothers hardware occupied this space. In 1907, Robert Orr & Co., a grocery firm, was in the building. In 1950 the Southern Woodenware Co., operated by Gilbert S. Merritt, worked from this location. Today, several shops are in business here.

12. Spring Brook Building, 154–162 Second Avenue

Spring Brook Building, 154–162 Second Avenue North.

The Spring Brook Building, erected in 1869, has housed McCrea & Co. cotton and tobacco factors and commission merchants and the Orr Brothers wholesale grocers and liquor merchants.

The Old Spaghetti Factory was one of the first adaptive reuses on the street.

13. Cheek-Neal Coffee Co., 148–152 Second Avenue

The Cheek-Neal Coffee Co., the originators of Maxwell House Coffee, worked from this location beginning in 1901. They learned to blend coffee beans to buffer and improve the flavor. The Nashville Sash and Door was the last of the warehouse firms in the building.

14. ATT Building, Fourth Avenue and Commerce Street

The "Batman Building," or the ATT Building, was erected in 1994 by Earl Swensson Associates and became an instant icon for Nashville. Baker Donelson Bearman Caldwell & Berkowitz law firm is the anchor in the building at 211 Commerce Street, which was also designed by Earl Swensson Associates. Former White House Chief of Staff Howard Baker is a principal in the firm. He was a U.S. senator from Tennessee, was the Republican Senate leader during the Watergate investigations and was also the Senate majority leader.

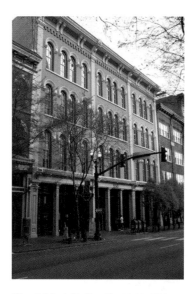

Cheek-Neal Coffee Co., 148–152 Second Avenue North.

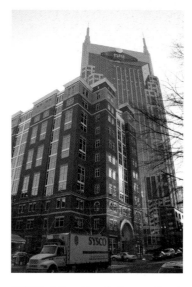

ATT Building, Fourth Avenue North at Commerce Street.

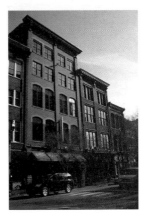

H.G. Lipscomb & Co., 138–142 Second Avenue North.

15. H.G. Lipscomb & Co., 138–142 Second Avenue

H.G. Lipscomb & Co., a wholesale hardware business, opened in this location in 1892. The company had the longest history of any firm on Second Avenue in one location, and operated here until the street changed to retail, office and residential space.

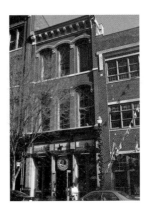

Charles Nelson & Co., 134–136 Second Avenue North.

16. Charles Nelson & Co., 134–136 Second Avenue

Beginning in 1888, Charles Nelson & Co. distributed spirits from Greenbrier Distillery and also sold whiskies and fruit brandies. Nelson had his office at the back, which was partitioned off with stained glass and had oak paneling and a fireplace.

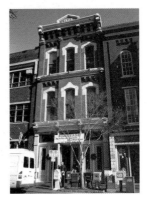

T.M. DeMoss & Sons, 126 Second Avenue North.

17. T.M. DeMoss & Sons, 126 Second Avenue

T.M. DeMoss & Sons occupied this building in 1938 and remained until the street changed to retail outlets. The building dates to 1875. Until it was renovated for offices, the building had a hydraulic, or water-powered, elevator. To go up you turned on a tap and a large drum would fill with water that would push a piston rod and lift the cage. When you wished to come down, the plug was removed and as the water drained you descended. It was fun to ride in it, and definitely unique.

18. Wildhorse Saloon, 116–124 Second Avenue

The Wildhorse Saloon was created by demolishing older buildings to make room for a dance club. Gaylord Entertainment, the owners of the Grand Ole Opry, Opryland Hotel and the Ryman Auditorium, owns the club.

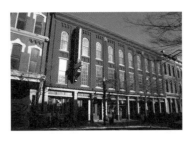

Wildhorse Saloon, 116–124 Second Avenue North.

19. Watkins Block, 108–114 Second Avenue

The Watkins Block, erected in 1880, now houses the Hard Rock Café, Market Street Emporium, a shop owned by Charlie Daniels and a residence. Samuel Watkins, a brick manufacturer and later the president of the Nashville Gas & Light Company, built the structure. Part of the old sign for Phillips and Quarles hardware store is still on the side of the building.

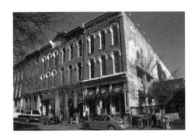

Watkins Block, 108–114 Second Avenue North.

20. Silver Dollar Saloon, 100 Second Avenue

One of the most distinctive buildings on the street is located at 100 Second Avenue North. It was designed by Julian G. Zwicker in 1893 as the Silver Dollar Saloon and catered to the riverboat men coming up from the wharf at the foot of Broadway. It has silver dollars in the floor of what was formerly the ground-floor barroom.

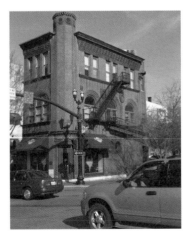

Silver Dollar Saloon, 100 Second Avenue North.

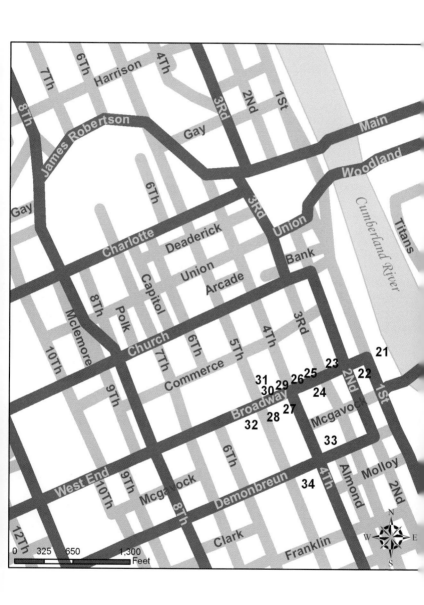

Tour Two

Lower Broadway

Lower Broadway is a commercial continuation of Second Avenue. Here were more of the warehouses and wholesale and retail stores that could be found around the corner. Beginning at the wharf, the street lay within the flood plain of the river bottom, and in fact was called Blackbottom due to the rich river flood-deposited soil found there. The riverboat crews would walk up the bank from the wharf and look for a bar to go to. The Silver Dollar Saloon was down on the corner, as were several others over the years, including the Bucket of Blood across the street on Broadway.

In time feed and grain wholesalers, ornamental plasterers and even some houses went up on Broadway. As the twentieth century progressed and the Grand Ole Opry moved into the Ryman Auditorium, more bars, record stores and furniture stores appeared on Broadway between the river and Sixth Avenue. The Greyhound Bus Station was up on Commerce Street, across from the Ryman, and tourists and musicians with a dream would show up to walk these streets. You could take in the early performance at the Ryman and then go to Tootsie's Orchid Lounge for a beer afterward. There you might see some of the performers from the Grand Ole Opry coming in the back door from the Ryman's stage door across the alley, and share a drink and conversation with them. From the 1940s to the 1970s, after the second show on Saturday night, Ernest Tubb would have some of the Opry cast over to his record store to sing and to sign autographs on the records that were for sale there.

Today the Ryman still has concerts and the Sommet Center hosts concerts as well as the Nashville Predators hockey team. They all call Lower Broadway home. The visitors' center is located there, and so is the Tennessee Sports Hall of Fame. Around the corner are the Country Music Hall of Fame and

Museum, the Musicians Hall of Fame and Museum and the Schermerhorn Symphony Center. On a weekend night this is a very busy part of town. On a warm night you can walk down to Riverfront Park and enjoy the view, or go up on the Shelby Avenue Pedestrian Bridge for a wonderful view of the city. From the 1940s to the 1970s, this was the home to country music and its fans.

THE NASHVILLE WHARF

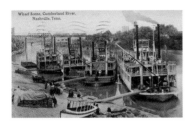

The Nashville Wharf around 1900.

The Nashville Wharf was at the foot of Broadway, where Riverfront Park is today. Around the turn of the twentieth century, that area was a very busy spot. The Cumberland River was navigable to river packet boats hailing from as far as Burnside, Kentucky. Thomas Green Ryman owned the Nashville and Cairo Packet Company, one of the largest riverboat companies operating on the Cumberland River at the turn of the last century. He lived in a house up near the University of Nashville on Second Avenue South, facing Lea Street, across from the site of the former Rutledge home, Rose Hill. He used the old well for Rose Hill, and when he had his house built, he had an outhouse built of brick with two divided sides, graduated size seats and a fireplace on each side. The sanitary pit was so large that it could be used for one hundred years. In 1981, Historic Nashville, Inc. led an archaeological dig at the site of the well and the outhouse. The objects uncovered are now at the Tennessee State Museum, and some of the Ryman family pieces are exhibited at the Ryman Auditorium.

21. RIVERFRONT PARK

Riverfront Park was built in the 1970s in order to reconnect the citizens of Nashville with the river. Concerts are held there during the warm weather months. Every June, the country music stars hold an event at the State Fairgrounds so they can meet their fans, and they give concerts here along the river and also out at the fairgrounds. The *General Jackson Showboat* takes a dinner cruise from Opryland to the park, and then back to Opryland. The *Delta Queen* is docked here periodically on cruises,

Riverfront Park.

and is the last overnight paddlewheel steamboat on American waters. There are also docking facilities for private boats.

22. Acme Farm Supply, First Avenue and Broadway

Acme Farm Supply operated from the southeast corner of Broadway and First Avenue for nearly one hundred years. It opened there in 1907. It was a direct link to the shipping, farm produce and other early businesses that were tied in with commerce up and down the river. You could buy straw, feed, wire, tools or just about anything that a farm supply store usually carries.

23. Broadway National Bank, 300 Broadway

On this site was fought the Battle of the Bluffs on April 2, 1781. It was the last major Chickamauga attack on the

Acme Farm Supply, First Avenue North at Broadway.

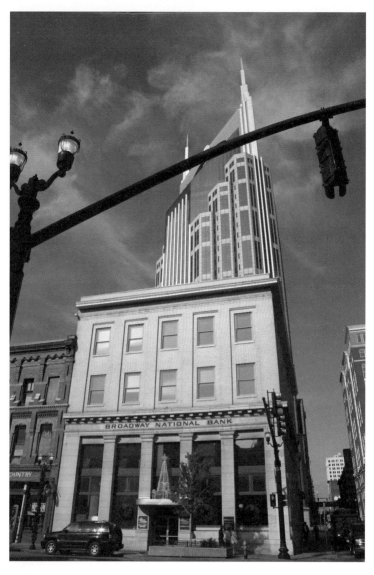

Broadway National Bank, 300 Broadway.

Cumberland settlements. The men were out hunting, and as they were returning to the fort, Chickamaugas ambushed them from the thick canebrake that grew here in the flood plain of the river. Charlotte Robertson, the wife of one of the founders of Nashville, heard the fighting from the fort and released dogs from the fort. The dogs attacked the Indians, and the settlers were able to return to the safety of the fort. On the Broadway side of the building is a marker for the battle. On the Third Avenue side is a marker for the homesite of Timothy Demonbreun, the

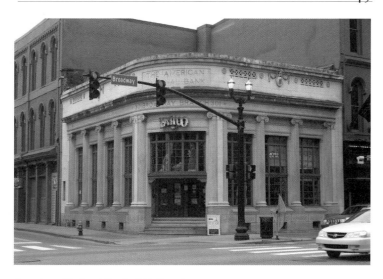

American National Bank, 301 Broadway.

first European settler in Nashville. The Matthews Company, a contracting firm, now operates from this building.

24. AMERICAN NATIONAL BANK, 301 BROADWAY

The American National Bank has seen many uses over the years. It was used by the *Nashville Scene* newspaper at one time, and is now a tattoo parlor. It is a stately vestige of when riverboats needed a bank, and so did the furniture stores, bars, musicians and tourists who were down on Broadway. It has classical stone pilasters, a large cornice, shields and garlands and florets as ornamentation.

25. BOOT COUNTRY, 304 BROADWAY

Lower Broadway was where people attending the Grand Ole Opry, at the Ryman Auditorium, would hang out from 1943 to 1974. It had honky-tonk bars, pawn shops, furniture stores and tourist-related shops. Boot Country is a newer business, but it reflects that history. The cast-iron columns are beautiful, with roses cast into the capitals at the

Boot Country, 304 Broadway.

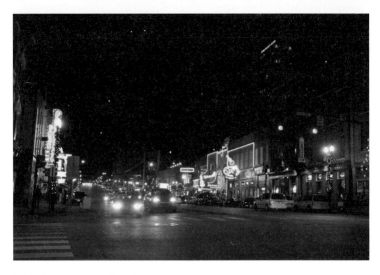

Nighttime on lower Broadway.

top, and decoratively painted. Notice the next two storefronts, and how theirs are painted in different colors.

26. Hatch Show Print, 316 Broadway

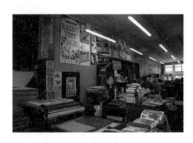

Hatch Show Print, 316 Broadway.

Jim Sherraden operates Hatch Show Print. It has been printing show posters for most of the twentieth century, and continues to do re-strikes of historical works today. They also do original work on commission. It is fun to watch the process; go on in and look around. You will see posters of Roy Acuff, Patsy Cline, Eddy Arnold, Louis Armstrong, Wolcott's Rabbit Foot Minstrels, Nine Inch Nails and Marilyn Manson. Very eclectic, very fun.

27. Merchants Hotel, 401 Broadway

The Merchants Hotel was built in 1892 as a place for traveling businessmen to stay. It is now a restaurant. When it was being renovated, letters from the Civil War were found in the walls from someone who had stayed there decades after the war. They are framed in the lobby.

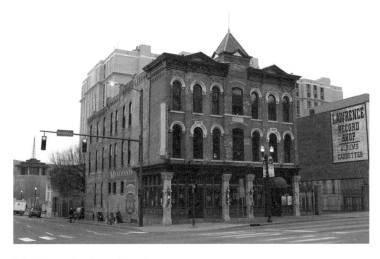

Merchants Hotel, 401 Broadway.

28. Ernest Tubb Record Shop, 417 Broadway

Ernest Tubb Record Shop has been on this site for over sixty years. The *Midnight Jamboree* is the second oldest continuously broadcast radio program. Following the late show at the Opry on Saturday night, performers would walk over to the record shop to perform and to sell their records. Patsy Cline, Carl Perkins, Johnny Cash and Loretta Lynn have all been here. It is still going on. The buildings at 417–423 Broadway are all music venues and bars. The buildings date back to the 1850s, when William Stockell had an ornamental plaster business there. He did the plaster work at the Tennessee State Capitol and at Belmont Mansion. During the Civil War, this building was part of Hospital No. 3, which had 250 beds in it for the care of the wounded and sick.

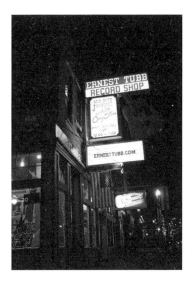

Above and below: Ernest Tubb Record Shop, 417 Broadway.

29. Friedman's Pawn Shop, 420 Broadway

The Second Fiddle Honky Tonkin is in the old Friedman's Pawn Shop. Musicians used to pawn their possessions here to get through the lean times while trying to get started in the music business. For many years Friedman's was there, beginning in this building in 1923.

Friedman's Pawn Shop, 420 Broadway.

30. Tootsie's Orchid Lounge, 422 Broadway

Tootsie Bess ran Tootsie's Orchid Lounge beginning in 1960. Such performers as Willie Nelson, Kris Kristofferson and Roger Miller were fed and "watered" there as they started out as struggling musicians. Go upstairs and see the door that Opry performers used to come in through from the stage door of the Opry across the back alley. After a visit to Tootsie's, the audience and the performers at the Opry were both a bit more lively.

Tootsie's Orchid Lounge, 422 Broadway.

31. Ryman Auditorium, 116 Fifth Avenue

The Ryman Auditorium, originally called the Union Gospel Tabernacle, was built by Hugh Cathcart Thompson for Captain Thomas Green Ryman in 1892. It was to be used as a revival hall for evangelist Sam Jones. At Ryman's funeral in 1904, Sam Jones called for renaming it the Ryman Auditorium. Originally there was no balcony, and the curved pews surrounded a pulpit, and a small

LOWER BROADWAY 53

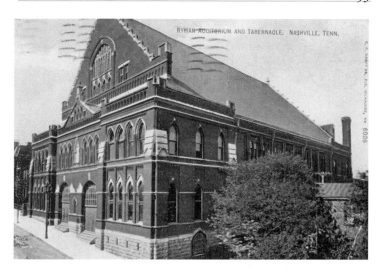

This page: Ryman Auditorium, 116 Fifth Avenue.

platform. Preparing for the Tennessee Centennial Exposition in 1897, the Confederate Veterans Association planned a meeting to be held in Nashville. The Confederate Gallery was then added to hold part of the anticipated turnout of 60,000 to 100,000 veterans. After the convention, the veterans donated funds to cover the cost of the new balcony. It was then the largest assembly hall in the South.

The stage was added in 1901 in order to allow the Metropolitan Opera to perform *The Barber of Seville* in the Ryman. This reduced the seating capacity to 3,500. In 1904, more work was done on it so that the French Opera Company of New Orleans could perform there. In 1906, dressing rooms and property storage space were added for a performance by Sarah Bernhardt as Camille. The Boston, Chicago and New York Symphony Orchestras performed there, as did John Philip Sousa. Victor Herbert conducted his orchestra there in 1903. John McCormack, Ignacy Jan Paderewski, William Jennings Bryan, Carry Nation, Emma Calvé, Booker T. Washington, Helen Keller and Annie Sullivan, Anna Pavlova, Luisa Tetrazzini, Alma Gluck, Amelita Galli-Curci, Enrico Caruso, Billy Sunday, Maurice Evans, Katherine Cornell, the Barrymores, Helen Hayes, the Ballets Russes, Ziegfeld Follies, Maude Adams, Marian Anderson, Arthur Rubenstein, Bob Hope and Doris Day all stood on that stage. During most of that time, Lula Naff booked the acts into the auditorium and kept all of the proceeds in an old shoe box.

From 1943 to 1974, it was called the Mother Church of Country Music and staged the Grand Ole Opry. Its stage door and Tootsie's Orchid Lounge's back door were across the alley from each other. The performers and audience could have a drink together between shows on Friday and Saturday night performances.

32. SOMMET CENTER, FIFTH AVENUE AND BROADWAY

The view of Nashville from the entrance to the Sommet Center.

The Sommet Center is the home of the Nashville Predators hockey team and is also a music venue. It houses the Tennessee Sports Hall of Fame and the Nashville Visitors' Center and has a wonderful view of the Ryman Auditorium and downtown Nashville from the bar upstairs.

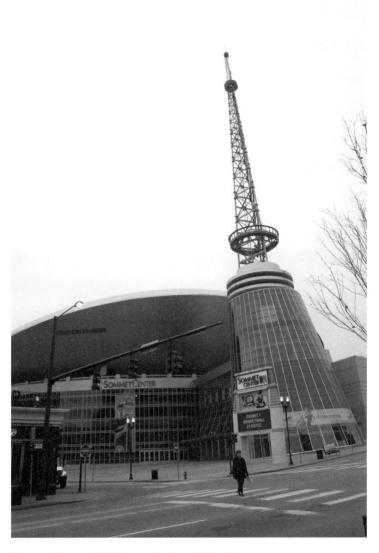

Sommet Center, Fifth Avenue South and Broadway.

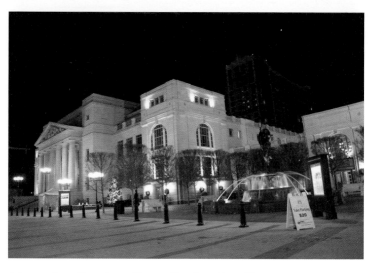

Schermerhorn Symphony Center, One Symphony Place.

33. Schermerhorn Symphony Center, One Symphony Place

The Schermerhorn Symphony Center is home to the Nashville Symphony Orchestra. The Tennessee state flower, the iris, is seen in the grilles on the exterior and interior, along with the state wildflower, the passionflower, on the exterior. Statues of Orpheus and Apollo are on the outside of the building and within its grounds. The Green Room, where performers relax before going on, has some beautiful Biedermeier furniture in it. The acoustics in the auditorium are phenomenal. There are three separate sets of walls to prevent street noise from getting into the building, and the windows are several inches thick, with an air lock in between two windows. This magnificent building is open for tours. The Shelby Avenue Bridge is beautifully illuminated at night, and is a pleasant place to walk and from which to view the city.

34. Country Music Hall of Fame and Museum, 222 Fifth Avenue

The Country Music Hall of Fame and Museum is a must-see stop for visitors interested in the musical heritage of Nashville. The architects were Tuck Hinton. The drum-shaped chamber to the east has a reduced replica of the WSM broadcast tower that made the Opry a national program on its clear channel Castle of the Air station. Atop the Hall of Fame chamber are

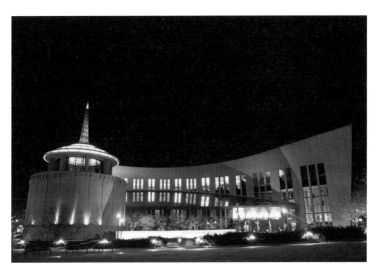

Country Music Hall of Fame and Museum, 222 Fifth Avenue South.

three discs, representing a $33^{1/3}$ recording, a 45 and a CD. The curving wall of the building is meant to reflect a keyboard. There are changing exhibits on specific artists, along with a permanent collection of Webb Pierce's car, Elvis's gold Cadillac, Minnie Pearl's hat and instruments from many stars. There is also a large research library open by appointment, which contains sheet music, handwritten music and sound recordings.

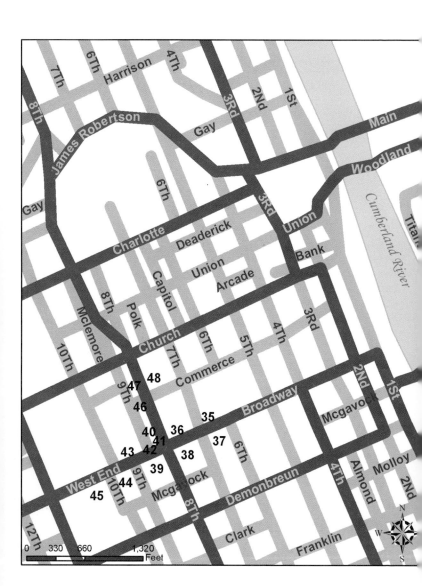

Tour Three
Upper Broadway

Upper Broadway was above the flood plain of the river bottom, and so the buildings up here are grander than their flood-prone neighbors downhill toward the river. Beginning at Seventh Avenue, there are much more substantial buildings, and these continue across the hill to the valley that the railroad uses to the west. Beginning with the U.S. Customs House in 1876, and continuing up until recently, this area continues to have some of the finest buildings downtown.

From the two Tiffany stained-glass windows in Christ Church Cathedral to the stained-glass barrel vault in Union Station and the modern stained glass in First Baptist, this area is one that is best appreciated from inside the beautiful buildings. The exteriors are wonderful, but the interiors are remarkable. So go to the buzzers at the entrance to the Grand Lodge, Christ Church Cathedral and First Baptist and ask to be allowed to see the interiors. You will be very happy that you did.

35. GRAND LODGE OF THE FREE AND ACCEPTED MASONS OF TENNESSEE, 100 SEVENTH AVENUE

The Grand Lodge of the Free and Accepted Masons of Tennessee was designed by Asmus and Clark, and built in 1925. The building may be accessed for touring. In the library is a set of portraits of former Grand Masters. The earliest ones are by Tennessee artist Washington B. Cooper, and include one of Andrew Jackson in his regalia. The lobby is covered in beautiful marble, as are the staircases leading up to the auditorium. The auditorium is a grand space where ceremonies and concerts are held.

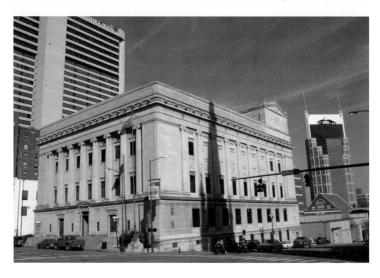

Grand Lodge of Free and Accepted Masons of Tennessee, 100 Seventh Avenue North.

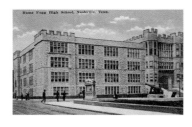

Hume Fogg High School around 1914, prior to the east wing being built.

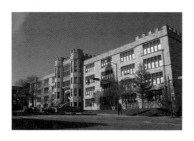

Hume Fogg Magnet High School, 700 Broadway.

36. Hume Fogg Magnet High School, 700 Broadway

Hume Fogg Magnet High School was designed in the Tudor Gothic style by William B. Ittner with Robert S. Sharp from 1912 to 1916. The entrance and western end were built first. Note the corbels over the entrance; dwarves holding academic symbols are carved into the limestone. William Hume and Francis B. Fogg were two of the early educators in Nashville. Two schools were built in the nineteenth century and were named to honor these men. Hume School was built by Adolphus Heiman in 1855 and was a castellated Gothic building. It stood on Eighth Avenue, toward the back end of the present building. Fogg School was built in 1874 as the first separate high school in Nashville. Both were torn

down to build the present school. Phil Harris, Pat Boone and Dinah Shore went to school here.

37. First Baptist Church, Seventh Avenue and Broadway

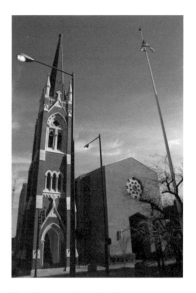

First Baptist Church relocated to this site in 1886, from Fifth Avenue North. The congregation had lost their building to the followers of Alexander Campbell when he formed a new sect from the Baptist congregation. Then the congregants moved to Fifth Avenue North, where the Bank of America stands today. That building was designed by Adolphus Heiman in the Gothic style between 1839 and 1841. In 1886, they moved into a much larger building at Eighth Avenue and Broadway. The tower that is there now

First Baptist Church, Seventh Avenue South and Broadway.

is from that earlier building that was designed by Hugh C. Thompson and Julian G. Zwicker. The Victorian Gothic church was demolished in 1967, and the new sanctuary was completed in 1970 by Edwin A. Keeble. The stained-glass windows were designed by Goode Davis, a student of Fernand Leger. Keeble also designed the office building at City Cemetery, Westminster Presbyterian Church, Vine Street Christian Church, Woodmont Christian Church, Immanuel Baptist Church and L&C Tower.

38. U.S. Customs House, 701 Broadway

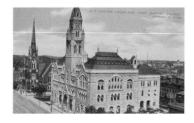

The U.S. Customs House was designed by William Appleton Potter. The cornerstone was laid by President Rutherford B. Hayes after he stole the election of 1876. He paid back the South for changing their Electoral College votes to him

U.S. Customs House, 701 Broadway.

rather than to Samuel Tilden, who had previously carried the vote in the South by promising to turn on the federal government building tap again to allow new projects to be built in the war-devastated region. The building was expanded twice. In 1902, the rear was added on in the same style, and it had a carriageway through the building. The two side additions were put into place in 1916–19. In the 1970s, the federal government sold it to Nashville for one dollar. Metro converted it into offices, leased them out and even leased the courtrooms to the U.S. Bankruptcy Court.

39. Estes Kefauver U.S. Courthouse, 800 Broadway

Estes Kefauver U.S. Courthouse, 800 Broadway.

The Estes Kefauver U.S. Courthouse was the original venue for the James Hoffa corruption and racketeering trial. The building opened in 1949, and the architect was Allen Stewart Thorn. It has a chocolate brown, granite-clad ground floor, and the upper floors are clad in limestone. The federal government used this design in a number of other cities, including Chattanooga.

40. Estel Gallery, 115 Eighth Avenue

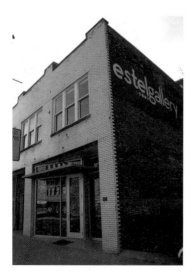

Estel Gallery, 115 Eighth Avenue North.

The Estel Gallery is located in recently renovated space. The owners live above the gallery.

41. Tennessee Art League, 808 Eighth Avenue

The Tennessee Art League is a gallery where members of the league can sell their work. To the east is an African art gallery.

42. Methodist Publishing House, 810 Broadway

Originally home to the Methodist Publishing House, this building has classical faces carved into the limestone corbels at the entrance.

43. Christ Church Cathedral (Episcopal), 900 Broadway

Christ Church Cathedral (Episcopal) was built in 1887–94. It was designed by Francis H. Kimball in the English Gothic style. The tower was completed in 1947. In 1888, the chapel, located to the rear, became occupied. That part of the building has a small bell tower to the south side of the Ninth Avenue North elevation. It is now used as the Parrish Hall. In 1891, the bell from the old church, located at Sixth Avenue North and Church Street, was hung in the chapel tower and rung for the first time in its new home on Easter Sunday. It had been cast by John Wilbank in Philadelphia in 1831.

The cornerstone to the new sanctuary was laid on September 7, 1892, by Bishop Charles T. Quintard. It weighs 5,555 pounds. On December 16, 1894, services were held for the first time in the new sanctuary. The building is made from sandstone that was a gift from the University of the South at Sewanee, Tennessee. The tower, trim and gargoyles are carved from Bowling Green stone. There are two Tiffany stained-glass windows in the clerestories

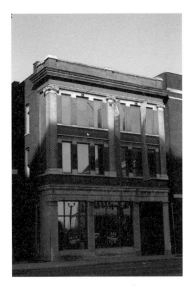
Tennessee Art League, 808 Eighth Avenue North.

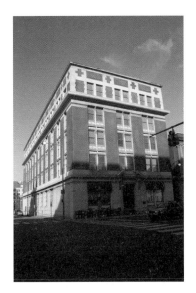
Methodist Publishing House, 810 Broadway.

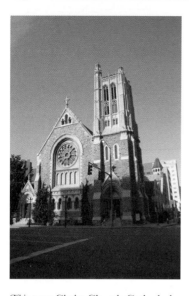

This page: Christ Church Cathedral (Episcopal), 900 Broadway.

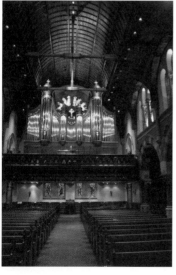

in the sanctuary. They are in the east, the second group of lancet windows; and in the west, the third group of lancet windows. Other windows are by Ascenzo, Geissler, Rambusch, Charles Booth, Charles Hogeman and Brenda Belfield. The reredos, altar and pulpit were made at the Edgefield and Nashville Manufacturing Co. and were carved by local Swiss resident Melchior Toni. The bronze angel lectern is signed by its sculptor, C.B. Upjohn, and was cast in 1895. The baptismal font was exhibited at the Scottish International Exhibition, held in Edinburgh in 1886. The baptistery contains the only known immersion pool in an Episcopal church in Tennessee. In 1998, Lively-Fulcher Organ Builders in Alexandria, Virginia, were commissioned to design a new organ and to move it into the balcony at the rear of the nave. It contains 3,370 pipes, 56 stops and 60 ranks.

44. Frist Center for the Visual Arts, 919 Broadway

The Frist Center for the Visual Arts is an art hall without ownership of a building or a collection. They rent art exhibitions and devote this magnificent space to the presentation of art from around the United States and abroad. The building belongs to the city. By not collecting, they can devote their funds and efforts toward bringing in a constantly changing display of collections from many museums. The building was designed by the local firm of Marr and Holman in 1934 as the main post office for Nashville in a New Deal Art

Deco style. It was connected to Union Station by a sky bridge, so that the mail could come directly into the building from the arriving trains across the street. At the rear were large loading dock doors for the mail trucks to then load out and distribute the mail. In the aluminum grills—in the former postal lobby where stamps were sold, postal boxes could be rented and packages were shipped—you can see the technologies for delivering the mail. To emphasize the speed with which the mail was delivered, there are trucks, trains and airplanes depicted. It was converted into an art hall by the local firm of Tuck Hinton.

This page: Frist Center for the Visual Arts, 919 Broadway.

45. UNION STATION, 1001 BROADWAY

Union Station opened in 1900 and was designed by L&N Railroad engineer Richard Montfort. Ground was broken for the building on August 1, 1898, and it was opened on October 9, 1900. It is in the Richardsonian Romanesque style, inspired by H.H. Richardson's Allegheny County Courthouse in Pittsburgh, Pennsylvania. It is clad in Bowling Green limestone and has a slate roof. To the rear is a baggage, mail and express building, which now has a brew pub in it.

The square front tower is 220 feet tall. It once had a three-dimensional statue of Mercury on top of the tower, but a storm blew it off in 1952. It was so badly smashed by its fall that it was not able to be repaired. Recently, a two-dimensional version has been put back on the top of the tower. The original statue had stood on the Commerce Building at the Tennessee Centennial Exposition.

The old train schedule board is still in the lobby, behind the hotel clerks' counter. The floor to ceiling rise in the lobby is 63 feet, to a barrel vault of stained glass. This space measures 67

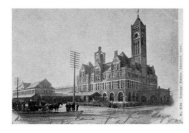

Above and below: Union Station, 1001 Broadway.

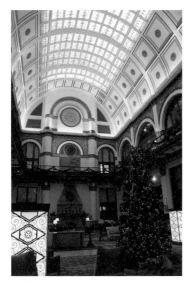

feet by 125 feet. The rail barn that was behind the building was 250 feet by 500 feet, and had a clear span of 200 feet. Ten full-length trains could sit beneath it. The station is raised up to the level of a viaduct in order to give the valley below to the trains. Trains ran beneath the station and unloaded freight and passengers at the rear under the shelter of the train shed. The end of the barn nearest to the station had lancet windows in frosted glass, with stained-glass roundels at the tops.

46. Southern Baptist Sunday School Board, 161 Eighth Avenue, and Publishing House, 127 Ninth Avenue

The Southern Baptist Sunday School Board and Publishing House are located on Eighth and Ninth Avenues. A statue of Billy Graham is at the corner of Eighth and Commerce Street, in a small park. The statue is by Terrell O'Brien and was erected in 2006. Next to this is the Frost Building, built in 1913 and designed by Gardner and Seal as the office building for the Sunday School Board.

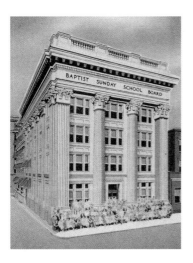

Southern Baptist Sunday School Board, 161 Eighth Avenue North.

47. The Standard, 167 Eighth Avenue

The Standard at the Smith House is a restaurant in an 1859 townhouse. It was the Savage/Zerfoss House, then a gay bar and bed-and-breakfast and now a restaurant. The Standard Club operated in the building in the early twentieth century as a Jewish club.

Southern Baptist Publishing House, 127 Ninth Avenue North.

48. Berger Building, 162 Eighth Avenue

The Berger Building, built in 1926, is a three-segment shop building, now housing several trendy stores.

Right: The Standard, 167 Eighth Avenue North.

Below: Berger Building, 162 Eighth Avenue North.

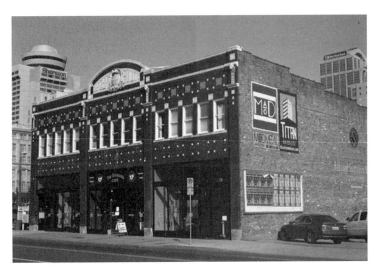

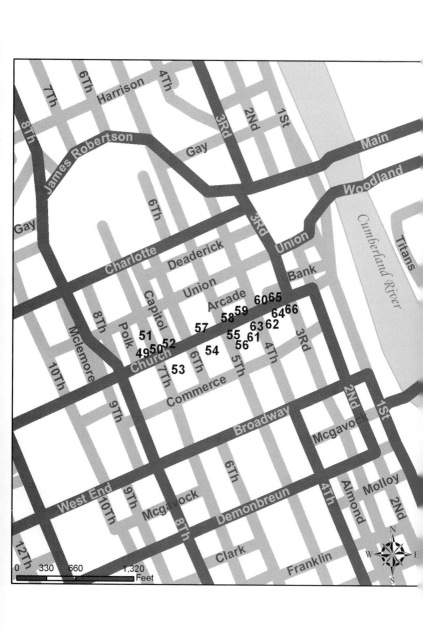

Tour Four
Church Street

Church Street has been many things over the years. It once was literally a street of churches, with Baptist, Presbyterian, Methodist and Episcopalian congregations worshiping along it. It was the main entertainment, shopping and medical area of the late nineteenth and most of the twentieth centuries. Here were the Sears, Castner-Knott, Harvey's and Cain-Sloan department stores. Phillips and Buttorff crystal, silver and china sold their beautiful things here. You could go to a movie at the Paramount, Tennessean, the Vendome or the Lowe's. You could eat at Shackelford's, Langford's, Harvey's basement, Cain-Sloan's Iris Room or the Captain's Table. You could visit your doctor or dentist, go by the offices of the three newspapers operating in the city, visit the Watkins Institute or take a class there after work, and probably see a score of people who you knew while you were there. It was the shopping street for Nashville. At Christmas, it was the place to pick out all of your presents.

Today it is changing into a residential and business street. The Jackson Building at Fifth and Church was built in the 1890s. It was a harbinger of what would come over a century later. It had a restaurant on the ground floor and apartments upstairs. The Noel Hotel still stands at Fourth and Church, and now a former bank across the street is a hotel, while the Noel houses offices. The Viridian offers high-end condominiums and a grocery store on the ground floor. More moderately priced condominiums are also available on the street. The Doctor's Building is now a hotel. The new Federal Courthouse is to be built across the street from it. So the street continues to evolve.

49. Doctor's Building, 710 Church Street

Doctor's Building, 710 Church Street.

The Doctor's Building is a part of that past. It started out as the three-story, terra cotta clad structure where most of Davidson County's doctors had their offices. As it prospered, three more floors were added to the top, but the terra cotta that was ordered was not the same as the original, so the two halves do not match. It is now a Homewood Suites Hotel, with glorious up lighting at night. Designed in 1910 by Edward E. Dougherty, it is a Renaissance-inspired confection. Dougherty also designed Belle Meade Country Club and the War Memorial Building.

50. Bennie Dillon Building, 700 Church Street

Bennie Dillon Building, 700 Church Street.

The Bennie Dillon Building was erected in 1926 by Asmus and Clark. It too is terra cotta clad, and was built to house a growing medical community. It is now condominiums.

51. YWCA Building, 211 Seventh Avenue

The former YWCA building on Seventh Avenue North sits on part of the property that President James K. Polk's home once stood upon. The president originally owned all of the block from Eighth Avenue to Seventh Avenue, and from Church Street to an alley where Union Street is now. Polk Avenue is the location of the old driveway up the hill to the house. The president and former first lady were buried in the back garden where the restaurant now stands at Seventh and Union. The former YWCA is now an office building. There is an inglenook in the lobby, where young women's dates could wait

for them to come downstairs from their rooms upstairs. The YWCA gave young working girls a place to start life in Nashville.

52. CASTNER-KNOTT DEPARTMENT STORE, 618 CHURCH STREET

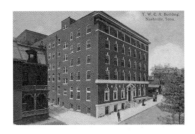

YWCA Building, 211 Seventh Avenue North.

The former Castner-Knott Department Store was one of the retail anchors in downtown Nashville into the 1980s. It eventually consisted of two buildings, side by side, between Seventh Avenue and Capitol Boulevard. At the turn of the last century it had streetcars, carriages and cars outside its doors, bringing people to shop there. Prior to that, the Felix DeMoville home stood here from 1857 to 1902. General Rousseau used it as his headquarters during the Union occupation in the Civil War. It was torn down to be replaced by the building now standing on this site.

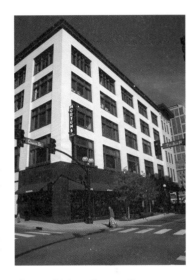

Above and below: Castner-Knott Department Store, Seventh Avenue North and Church Street.

53. NASHVILLE PUBLIC LIBRARY, 615 CHURCH STREET

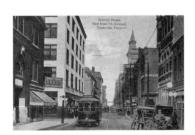

The Nashville Public Library, located at 615 Church Street, was designed by Robert A.M. Stern in 2001. It has a grand main reading room, a large children's library, a children's marionette and puppet theater, a civil rights room, the Nashville Room (for local history) and wonderful murals by Richard Haas, which depict the growth of Nashville from frontier settlement to today. There is also an atrium garden upstairs, which is a restful place to relax.

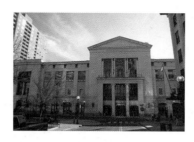
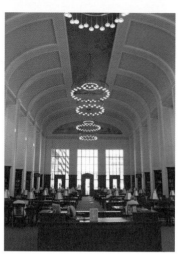

Above and right: Nashville Public Library, 615 Church Street.

54. McKendree Methodist Church, 523 Church Street

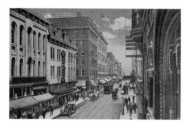

One block west of McKendree Methodist Church around 1900.

The former façade of the McKendree Methodist Church.

McKendree Methodist Church has occupied this site since 1833, and it is the oldest congregation in Nashville. Look to the left side of the building and you can see where the building had fifty feet added onto it in 1966–67. The former façade had two towers with cupolas, and a dome in the center. It was erected between 1907 and 1910. In 1910, the Von Guerthler Art Glass Company was commissioned to create ten stained-glass windows portraying the life of Christ. A Christian Life Center was added to the rear in 1990 for day-care and exercise facilities. The block around McKendree was made up of the Watkins Institute, an adult education center, department stores, jewelers and the Jackson Building, an 1890s residential block with shops on the ground floor.

McKendree Methodist Church, 523 Church Street.

55. The Downtown Presbyterian Church, 154 Fifth Avenue

The corner of Fifth and Church has had a Presbyterian church on it since 1816. This is the third building to occupy that site. Designed by renowned architect William Strickland, it is a National Landmark building. Built between 1849 and 1851, it is in the very unusual Egyptian Revival style. In fact, it could be a set for the opera *Aida*. During the Civil War, the building was seized by the Federal government and converted into part of Hospital No. 8. It contained 206 beds. Interestingly, the hospital closed a public latrine located beside the church, which had twenty-six seats in it. A sanitary report complained of the smell coming from it in the heat of summer. So the army filled the sanitary pit in and built a two-story outhouse at the back corner to the church. It had four seats upstairs and four more downstairs. The elbows to the drains were made of leather and leaked. The catchment was a large wooden box that needed to be pulled out and dumped. That went into a cart, and leaked all over the streets. So the army made a bad situation worse.

The bell in the tower was presented in 1867 by Adelicia Acklen, and at two tons, is still the largest one in Davidson County. Be sure to also look at the Education Building, located to the rear on Fifth Avenue. In the center of it is a four-story rise with a coffered dome and an oculus. It was designed by Henry C. Hibbs in 1917. The congregation had a long history of service to the community. During the great floods of 1927 and 1937, flood victims were housed in the church. During World War II, with troop training exercises for the Normandy landings being held nearby, and with

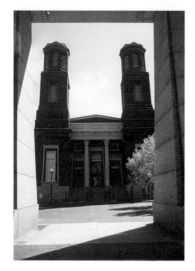 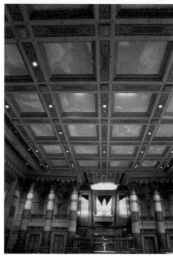

Above, left and right: The Downtown Presbyterian Church, 154 Fifth Avenue North.

several military bases nearby, Nashville was very crowded when they were on leave. So the church opened up as a place for military personnel to sleep. Showers were even added for them to use.

Following *Brown v. Board of Education*, the majority of the congregation voted to relocate to the town of Oak Hill, to the south of Davidson County, which by statute was white only. The more enlightened element stayed and formed The Downtown Presbyterian Church in 1954. When First Presbyterian Church of Nashville moved to Oak Hill, they took the name with them to that new town. They said that history attaches to a name, not the place where it happened, and that the new congregation had no past. So the First Presbyterian Church congregation painted out the panels on the exterior of the church that listed all of the ministers to have served there and all of the churches to have been sent out from there, and chiseled the name off the Education Building. They pulled the marble memorial plaques to three ministers who had preached there off the vestibule wall, and in doing so they shattered all of them. The National Trust for Historic Preservation met in Nashville and persuaded First Presbyterian not to sell the land for demolition and the erection of a parking garage. They instead sold the building to the members who wished to remain.

Continuing its service to the community, the church now has a homeless ministry and fed nearly eleven thousand meals to the homeless in 2007. There are artists' studios in the Education Building on the third floor. Following the 1998 tornado, the governor and mayor held a prayer service in the church. Andrew Jackson was presented with a ceremonial sword by the State of

Tennessee on the front steps to the first church to stand here. James K. Polk was sworn in as governor in the second building. Governors McWherter and Bredesen each had their inaugural prayer services in the building. When Governor McWherter's former aid, Jim Kennedy, died, his memorial service was held here, so that the Tennessee General Assembly and other government officials could walk to the service. When Mayor Purcell wanted the Sister Cities delegates to worship together in 2006, he asked to hold that service here. The mayors of Caen, France; Magdeburg, Germany; and Belfast, Northern Ireland, all took communion and worshiped together here. The city has held conferences and preservation awards ceremonies here as well.

56. COHEN BUILDING, 421 CHURCH STREET

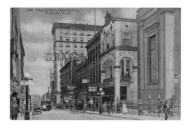

Cohen Building, 421 Church Street.

The Cohen Building stands beside The Downtown Presbyterian Church, to its east. Meyer and Etta Brinkley Cohen lived on the two upper levels, which had parquet floors, fireplaces in every room, stained-glass windows (see one of them in the Tennessee State Museum) and wainscoting. On the first floor, Meyer Cohen ran a jewelry store. Mrs. Cohen enjoyed the balcony on her bedroom, fronting on Church Street.

57. SAINT CLOUD CORNER, 500 CHURCH STREET

Saint Cloud Corner, 500 Church Street.

Saint Cloud Corner takes its name from the St. Cloud Hotel, which was built at the northwest corner of Fifth and Church prior to the Civil War. Just prior to the Battle of Nashville, U.S. General George Thomas, who was staying at the hotel, paid his bill and checked out—just in case he did not return from the battle. The Cain-Sloan Department Store occupied the present building until the 1950s.

58. Fifth & Third Bank Building, Fifth Avenue and Church Street

Kohn Pedersen Fox Associates designed the Fifth & Third Bank Building in tribute to The Downtown Presbyterian Church, across the street from its site, in 1986. Knowing that a National Landmark was facing it, they made the bottom floors in a neo-Egyptian style.

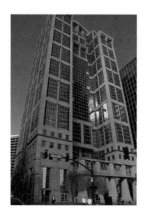

Fifth Third Bank Building, Fifth Avenue North and Church Street.

Maxwell House Hotel, formerly at Fourth Avenue and Church Street

The corner of Fourth and Church has seen many changes over the years. The Maxwell House Hotel stood at the northwest corner from 1859 to 1961, when it burned on Christmas Day. Some pieces of its original cornice are exhibited at the Tennessee State Museum. During the Civil War, it was used as a hospital and a prison for Confederate POWs. Completed in 1869, after its construction was halted by the war, it became one of the premier hotels in the South. It was so prestigious, in fact, that a local businessman asked to market his new blend of coffee using the hotel's name. Thus was launched Maxwell House Coffee.

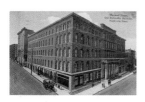

Maxwell House Hotel, formerly at Fourth Avenue North and Church Street.

59. Third National Bank Building, Fourth Avenue and Church Street

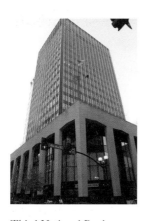

Third National Bank Building, Fourth Avenue North and Church Street.

Following the loss of the Maxwell House Hotel, the Third National Bank built a new headquarters in 1968, designed by Brush, Hutchison & Gwinn. This was one of the first buildings with setbacks and landscaping in Nashville. Sun Trust Bank is now the owner of the bank and the building.

60. Noel Hotel, 200 Fourth Avenue North

The former Noel Hotel has been used as a hotel, several banks and offices. Behind it and across the alley is its former parking garage. Built in 1930 by Marr and Holman, and renovated in 1973, the lobby is marble and brass with crystal chandeliers. Turner Publishing is one of the businesses located in this building now.

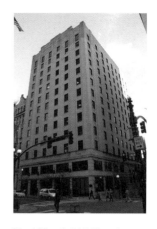

Noel Hotel, 200 Fourth Avenue North.

61. Viridian Building, 415 Church Street

The Viridian opened in 2006, and at thirty-one floors, was the first high-rise downtown since the Batman Building went up in 1994. The architectural firm that designed it was Smallwood, Reynolds, Stewart, Stewart & Associates, Inc., based in Atlanta. It is a condominium and has a grocery store on the ground level, with parking available on the lower floors.

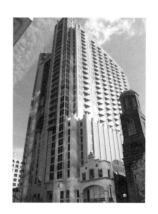

Viridian Building, 415 Church Street.

62. Third National Bank/ Courtyard by Marriott, 170 Fourth Avenue North

The front half of this building was erected in 1904 and was the first high-rise in Nashville, at twelve floors. The initial architects were Barnett, Haynes and Barnett. It was doubled in depth in 1936. Independent Life, Third National Bank, J.C. Bradford and now a Courtyard by Marriott suites hotel have occupied the building. Prior to the present building, the *Nashville American* newspaper stood here, with its back to an alley.

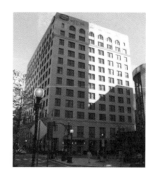

Third National Bank/ Courtyard by Marriot, 170 Fourth Avenue North.

63. L&C Tower, Fourth Avenue and Church Street

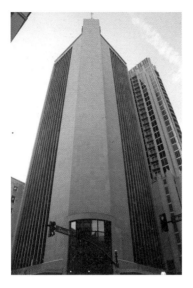

L&C Tower, Fourth Avenue North and Church Street.

The L&C Tower was designed in 1956 by Edwin A. Keeble and was the tallest building in the Southeast at that time. The sign at the top would forecast the weather reports by using red lights in the L&C sign for bad weather and green lights for fair weather. Keeble was an early advocate for passive solar buffering, which blocks heat from the sun by putting shields against the sides of windows. These are seen on the windows here and also in the overhangs he designed into Hillsboro High School's stacked floors.

64. *Nashville Banner* Building, Printer's Alley at Church Street

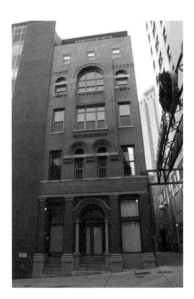

Nashville Banner Building, Printer's Alley at Church Street.

The former *Nashville Banner* newspaper building stands behind the Courtyard Marriott, and its side was along the alley that it shared with the *Nashville American* and the *Nashville Tennessean* newspapers. With three newspapers on one alley, it of course became known as Printer's Alley. Today condominiums occupy the building.

65. Printer's Alley, between Fourth and Third Avenues on Church Street

Nashville's first nightclub district was Printer's Alley. It is a bit like Bourbon Street in New Orleans, with music clubs, restaurants and strip clubs.

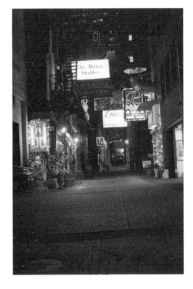

Printer's Alley, between Fourth Avenue North and Third Avenue North on Church Street.

66. Exchange Building, Church Street

The Exchange Building houses condominiums now, but was built for the Nashville Exchange Club offices.

Exchange Building, Church Street.

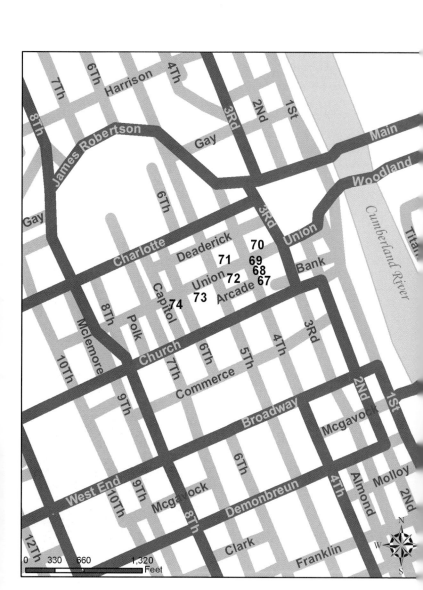

Tour Five

Fourth, Fifth and Sixth Avenues

Fourth, Fifth and Sixth Avenues were shopping streets one hundred years ago. Fourth Avenue was for men. It had shirt shops, bars, gambling and other "diversions." Fifth Avenue was a street with Skalowski's Ice Cream parlor; Thompson's fine china, crystal and linens; Connell, Hall & McLester's Department Store; the Arcade; and Calhoun's silver shop. The Kress store was there for more inexpensive items. On Sixth Avenue were fine jewelry and ladies clothing stores and Dury's photo shop. There was a cafeteria across the street from the Hermitage Hotel, and a fine restaurant in the hotel.

67. Utopia Hotel, 206 Fourth Avenue

The Men's Quarter in the 1890s was a street where no proper lady wanted to go. The Utopia Hotel, built at six floors in 1891, was put up in anticipation of crowds that would attend the Tennessee Centennial Exposition a few years later.

68. Climax Saloon, 210 Fourth Avenue

The Climax Saloon—what more can I say? Built in 1887,

Utopia Hotel, 206 Fourth Avenue North.

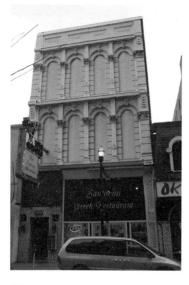

Climax Saloon, 210 Fourth Avenue North.

it catered "to a certain crowd." Liquor was available on the ground floor and gambling and other diversions were upstairs. With statewide Prohibition beginning in Tennessee in 1909, Mayor Hillary Howse was asked whether he and the police protected the bars on Fourth Avenue. He responded, "Protect them? I do better than that, I patronize them." As mayor of Nashville for twenty-one of the thirty years of Prohibition, he certainly did.

69. SOUTHERN TURF, 212 FOURTH AVENUE

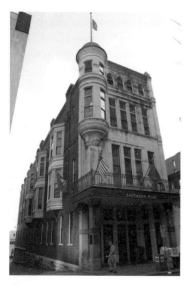

Southern Turf, 212 Fourth Avenue North.

The Southern Turf was reputed to have gambling, liquor and women. Built in 1895 by Marcus Cartwright and operated by Ike Johnson, it had mahogany, bronze sculpture, mirrors, paintings and tropical plants. After Prohibition was passed in 1909 in Tennessee, the building continued to function as a bar, protected by the mayor and police. In 1916, it was finally closed. Ike Johnson had managed it for years and lived on the third floor of the building. He could not accept such a change, and shot himself in his rooms on the third floor. From 1916 to 1937, the *Nashville Tennessean* newspaper occupied the building.

70. First American Bank/Regions Bank Building, 315 Deaderick Street

Regions Bank currently occupies the former First American Bank Building. The Bank of Tennessee, built in 1853 by Francis Strickland, the son of William Strickland, was the first bank on this site. It measured fifty by eighty-eight feet, and resembled the Second Bank of the United States, which was erected for Nicholas Biddle by William Strickland in Philadelphia in 1818–24. When the new building was being built on this site in 1971–73, Perkins and Mills of Chicago and John Charles Wheeler & Associates found a cave when digging the basement floors out. In it were Native American remains and part of a saber-toothed tiger. That is why the local hockey team is named the Predators, and why they use a saber-toothed tiger as their symbol.

First American Bank/Regions Bank Building, 315 Deaderick Street.

71. Doubletree Hotel and Bank of America, 315 Fourth Avenue

The Doubletree Hotel and Bank of America buildings were built together and form two triangles. They are reminiscent of I.M. Pei's idea for the east wing of the National Gallery of Art in the way the two form a cohesive unit. Set at a diagonal on the lot, there is a pleasant landscaped area between the two structures. The architects were Thompson, Ventulett & Steinback, Inc., and the buildings opened in 1977.

Doubletree Hotel and Bank of America, 315 Fourth Avenue North.

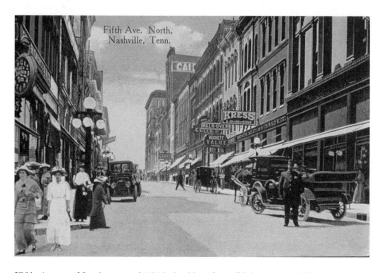

Fifth Avenue North around 1910, looking from Union toward Church Street.

Fifth Avenue North, looking from Union Street toward Church Street

Fifth Avenue was a street lined with mid- to lower-tier shops at the turn of the last century. The tallest building then was the Connell, Hall & McLester Department Store beside the St. Cloud Corner. It was built in 1898, and was one of the tallest buildings in town. Built as the first department store in the city, it did not go over well, and closed shortly thereafter. Cain-Sloan would occupy it later as a part of its new department store, and then Harvey's Department Store used that building. The interior originally had a skylight and an open atrium going from the roof to the first floor above ground. When Fred Harvey, who had worked for Marshall Field's in Chicago, came to town to open a new department store, he bought all of the buildings on the north side of Church Street between Fifth and Sixth Avenues North. They were all connected together, and a bridge of several stories spanned the alley at the middle of the block. He installed the first escalator in Nashville, and in the Connell, Hall & McLester Building used the atrium for the escalator and simply cut out the one additional floor to connect it to the ground level. He also purchased the carrousel from Glendale Park and used it as a symbol for his new store. He put the horses up on the exterior of the buildings on a canopy he had built to link all of them. At the other end of the street was a Kress 5-10-15 cent store. In the 1930s, Kress put up a new building where the original structures had been.

Fourth, Fifth and Sixth Avenues

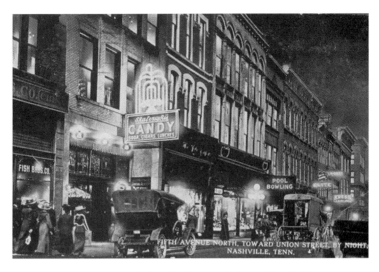

Fifth Avenue North around 1910, looking north from Church Street.

Fifth Avenue North, looking north from Church Street

Skalowski's Candy, Soda, Cigars, Lunches is still standing on Fifth Avenue North. It has white glazed bricks on the façade. Inside it had an onyx soda fountain, a musician's gallery at the rear and a Syrian tile fountain. Upstairs there were rooms that could be rented for parties. The Arts Company is located next door now, and uses some of this space for its art sales areas. It is at 217 Fifth Avenue North.

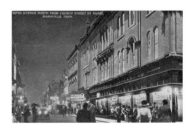

Above: Fifth Avenue North around 1910, looking toward the Arcade from Church Street. *Below:* The Arcade also around 1910.

72. Fifth Avenue North, looking toward the Arcade from Church Street

The Nashville Arcade runs between Fifth and Fourth Avenues, halfway up the block on each street. Opened in 1903 as Nashville's first "shopping

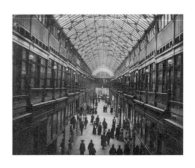

Rymer Gallery, 231–233 Fifth Avenue North.

center," it continues as a popular lunch place and shopping area today. It once had a large curved cornice over the entrance and was opposite and up a street from Skalowski's. The day it opened, around thirty thousand people attended. It was designed by Thompson, Gibel and Asmus, and the Edgefield and Nashville Manufacturing Company built its parts. It is 360 feet long, 84 feet wide and 56 feet high.

73. The Rymer Gallery, 231–233 Fifth Avenue

The Rymer Gallery is a newer gallery in town. This building was built as two stores, and now has condominiums on the upper floors.

74. The Hermitage Hotel, 231 Sixth Avenue North

The Hermitage Hotel, at the northwest corner of Sixth and Union, opened in 1910. J. Edwin Carpenter was the architect. It is Beaux Arts in style, and has a stained-glass skylight in the marble lobby. The entrance is clad in Sienna marble. The Grille Room once had the Francis Craig Orchestra, with Dinah Shore as their singer. Unfortunately, the beautiful cornice was removed and sold by Historic Nashville, Inc. When Gene Autry stayed at the hotel, he brought Trigger, his horse, with him, and Trigger had his own room. During the ratification debate for

the Nineteenth Amendment to the U.S. Constitution, granting women the right to vote, the women lobbying the Tennessee General Assembly for and against getting the vote stayed at the Hermitage Hotel. William Gilbert Gaul, a painter of national reputation who worked both here and in New York, sold a series of Civil War–inspired paintings to Robert R. Meyer, the owner of the hotel, and he had them hung in the lobby. Prints of the paintings were sold at the cigar stand in the lobby for many decades. In 1911, William Howard Taft gave a speech here.

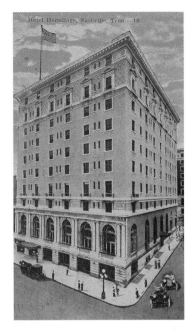

This page: The Hermitage Hotel, 231 Sixth Avenue North.

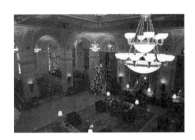

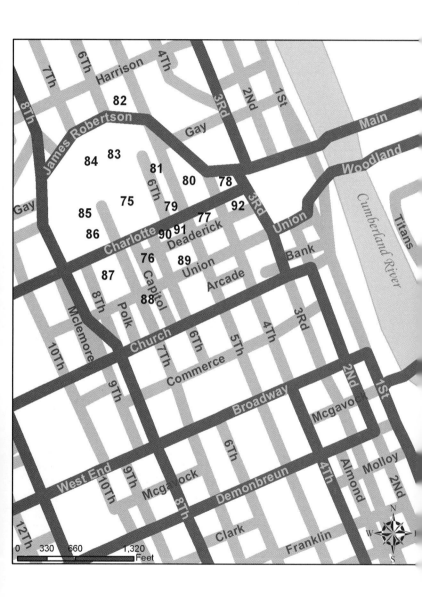

Tour Six
Tennessee Government

Nashville was chosen as Tennessee's permanent capital in 1843. Prior to that, the legislature had met in Knoxville and Murfreesboro. Beginning in 1827, it had been meeting in the Davidson County Courthouse. So when the city of Nashville purchased the tall hill up from the courthouse and offered it to the state as a free location to build the capitol on, the state accepted the offer. The Cumberland River also made it easy to reach Nashville, and the city was the largest settlement in the middle of the state.

Over the years, government has grown on all three levels here—federal, state and local. The Tennessee government complex of buildings is the largest governmental grouping of buildings in town. The Tennessee State Capitol is the oldest and grandest of all of these. The Andrew Johnson Building is the newest. The John Sevier State Office Building has a pair of wonderful Dean Cornwell murals in the main lobby. The Cordell Hull State Office Building has four groupings of bronze statues at the entrances on Sixth Avenue North and on the north end of the building, celebrating the state's history and people. The War Memorial has monuments to Tennessee's war dead from the First World War, Korean War and Vietnam War, as well as a monument to Confederate women. The Tennessee State Museum is located in the Polk Center, and is free and open to the public. It contains 120,000 square feet of exhibition and support areas. In the ground floor of the War Memorial Building is the Military Annex of the museum. It too is free and open to the public. The Polk Center also contains the Tennessee Performing Arts Center, with three auditoriums for ballet, theater and concerts. Admission is charged for these events.

Nestled within this complex are several other important buildings. The first Roman Catholic cathedral in Tennessee, St.

Mary's of the Seven Sorrows, is an Adolphus Heiman–designed 1847 structure. The Morris Memorial Building is an important African American banking and publishing site. The Municipal Auditorium is another sports, music and entertainment site. The Tennessee Tower is one of the tallest buildings in town, and the Sheraton is a former Hyatt Hotel with one of their signature atriums from the 1980s.

75. Tennessee State Capitol and Clark Mills Statue of General Andrew Jackson, Sixth Avenue North at Charlotte Avenue

Tennessee State Capitol and Clark Mills equestrian statue of General Andrew Jackson.

The Tennessee State Capitol was designed by William Strickland and is a National Landmark. Erected between 1845 and 1859, it is in the Greek Revival style. Strickland was convinced that it was his finest work, so much so that he is buried within the northeast corner of the building. The building chairman, Samuel D. Morgan, is buried in the southeast corner. President and Mrs. James K. Polk are buried on the front lawn. Nashville has been the seat of Tennessee government since it became the permanent capital in 1843. The legislature first met in this building while it was under construction in 1853 and has met there ever since.

The two most important events to take place in the building enfranchised about 57 percent of the population of this country. The Fourteenth and Fifteenth Amendments to the U.S. Constitution were ratified here. Tennessee's Reconstruction governor, William Gannaway Brownlow, swayed Congress to allow Tennessee back into the Union by forcing through the legislature the passage of the Fourteenth Amendment in 1866. Then the Fifteenth Amendment gave African American men the right to vote. In 1920, Tennessee was the last hope for women to get the right to vote. Thirty-six states needed to ratify the Nineteenth Amendment, and thirty-five had done so, when the Tennessee General Assembly was called upon to vote by Governor A.H. Roberts. Of the thirteen remaining states, most were like Minnesota, and were firmly against women voting. The entire lobbying efforts of everyone in the country who was either for or against women voting was focused that summer

on the Tennessee General Assembly. It came down to two votes and two differing viewpoints deciding the issue. Representative Harry Burn changed his mind and changed his vote to yes, and that ratified the amendment. He had initially voted no, but when his mother sent him a note asking that he consider giving women a chance, he changed his vote to yes. So women can vote due a legislative act in Tennessee, and so can African American men. This accounts for around 57 percent of today's population.

THE FORMER TENNESSEE STATE LIBRARY IN THE CAPITOL

The Tennessee State Capitol underwent a restoration of the interior in the 1980s and has had further restoration work done since then in the House and Senate Chambers. The former State Library chamber is the most colorful room in the capitol, and it was completed by Harvey Akeroyd in 1859. The original lights in the building were manufactured by Cornelius and Company of Philadelphia, and the ornamental cast-iron work that is so exuberantly used in this room in particular was made by Wood & Perot of Philadelphia.

The former Tennessee State Library in the capitol.

The Tennessee Historical Society used this room for its collections until 1886, when they moved to the Watkins Institute on Church Street. The Egyptian mummy, governors' portraits, manuscripts and other treasures are now at the Tennessee State Museum.

PRESIDENT AND MRS. JAMES K. POLK'S TOMB

William Strickland designed the tomb for James K. Polk and his wife Sarah Childress Polk for their home garden, at the corner of Seventh and Union. But Jacob McGavock Dickinson bought the property and had them removed. The state then reburied them with honors at the state capitol. The president's home was demolished when Dickinson sold it to commercial interests who put up apartment buildings.

76. War Memorial Building, Sixth Avenue North

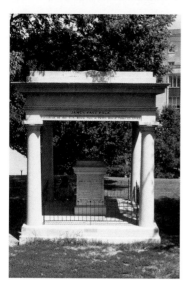

President and Mrs. James K. Polk's tomb.

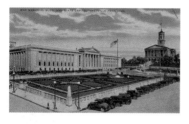

War Memorial Building, Sixth Avenue North.

The War Memorial Building was designed by Edward Emmett Dougherty and opened in 1925. He received an American Institute of Architects Gold Medal that year for its design. The center is an open courtyard housing tablets inscribed with names of 3,400 Tennesseans who died in the First World War. A heroic statue of Youth stands in the center of the courtyard, holding a Nike in his open left palm, symbolizing victory in the war. Belle Kinney Scholz was the sculptor of the statue. She also did the Confederate Women's Monument at the southwest corner of the building. To the south end of the large plaza in front of the War Memorial are monuments to the Korean War (built by Russ Faxon in 1992) and to the Vietnam War (built by Alan LeQuire in 1986). The military branch of the Tennessee State Museum is in the ground floor of the southern end of the building. From 1939 to 1943 the Grand Ole Opry used the auditorium.

77. St. Mary's Catholic Church, 330 Fifth Avenue

St. Mary's Catholic Church stands at the southeast corner of Charlotte Avenue and Fifth Avenue. The first Roman Catholic cathedral for Tennessee, it was built from plans by Adolphus Heiman from 1845 to 1847. It has been severely remodeled twice. Originally the tower had an open bell chamber, with four clock faces and four cruciform windows. Double volutes were at the base to the tower and at the top. A pediment was along each of the

long sides of the building, and the windows had ornamental moldings and caps at their tops. All but the cruciform windows were removed in a remodeling in 1926 by Asmus and Clark. They replaced the original brick and stucco columns on the front with carved limestone columns. The capitals are original. The original altar was also removed, along with the pews, frescos on the walls, the original gasoliers and the ceiling, windows and doors. Bishop Miles was buried beneath the altar and rested there until his remains were moved into the vestibule and placed in a large enclosed wooden container.

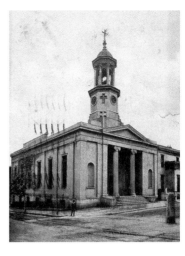

St. Mary's Catholic Church, 330 Fifth Avenue North.

78. Morris Memorial Building, 330 Charlotte Avenue

Morris Memorial Building, 330 Charlotte Avenue.

The Morris Memorial Building at Fourth and Charlotte was designed by the African American firm of McKissack & McKissack from 1923 to 1925. It housed one of the first African American–owned banks in the country, the One Cent Savings Bank, founded in 1904. The National Baptist Convention also has its publishing house located in the building. Religious publishing is a big business in Nashville, with the Southern Baptist, United Methodist, National Baptist, Thomas Nelson Publishers and Southwestern Company all being headquartered in the city. James Carroll Napier was one of the founders of the One Cent Savings Bank, which is now the Citizens Savings Bank and Trust Company. He was appointed by President Theodore Roosevelt to serve as registrar of the U.S. Treasury, and served from 1911 to 1915. He was a delegate to four Republican National Conventions, and was a trustee of Fisk, Howard and Meharry Universities.

79. John Sevier State Office Building, 425 Fifth Avenue

John Sevier State Office Building, 425 Fifth Avenue North

The John Sevier State Office Building was built at the same time as the Davidson County Courthouse and the Tennessee Supreme Court Building as a WPA building project. It was designed by Emmons H. Woolwine and was constructed between 1937 and 1940. There is a pair of Dean Cornwell murals in the entrance lobby that depict the themes of exploration and settlement. The murals portray heroes of the early history of Tennessee, such as James and Charlotte Robertson, Hernando de Soto, Jacques Marquette and Louis Joliette, Daniel Boone, Sam Houston, Andrew Jackson, James K. Polk, Andrew Johnson, Alvin York, Cordell Hull, Nathan Bedford Forrest, David Farragut and John Sevier.

80. Municipal Auditorium, 417 Fourth Avenue

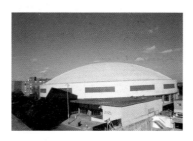

Municipal Auditorium, 417 Fourth Avenue North.

Down the hill from the state offices complex, between Fifth and Fourth Avenues, is the Municipal Auditorium. Built in 1962 by Marr and Holman, it has held everything from Bob Dylan concerts to the circus and rodeos. It can be seen from the roof terrace of the Central Services Building on Sixth Avenue North. This terrace was constructed in order to open a view of the front of the capitol for those approaching the city from the east.

81. Cordell Hull State Office Building, 425 Fifth Avenue

The Cordell Hull State Office Building is named for Tennessee's first Nobel Peace Prize winner. Hull was born in a log cabin in the Cumberland Mountains and was a congressman, senator,

secretary of state and founder of the United Nations. The building was designed by Hart and McBryde in 1952. There are four groups of bronze statutes at the west and north elevations. The ones on the front represent the eighteenth-century pioneers, the TVA and the Civil War. On the north end is a contemporary family group.

82. David Crockett and Andrew Johnson State Office Buildings, 500 and 710 James Robertson Parkway

Cordell Hull State Office Building, 425 Fifth Avenue North.

The David Crockett and Andrew Johnson State Office Buildings are on James Robertson Parkway and flank the entrance to the Tennessee Bicentennial Mall State Park. They can be seen from the drive and walkway around the north side of Capitol Hill. Johnson, Johnson and Crabtree were the architects of the David Crockett Building in 1985 and of the Andrew Johnson Building in 1991.

David Crockett State Office Building, 500 James Robertson Parkway.

83. The Belvedere, overlooking the Bicentennial Mall

From the Belvedere, or overlook, there is a view of the Tennessee Bicentennial Mall State Park. The Mall is the future home of the Tennessee State Museum and the Tennessee State Library and

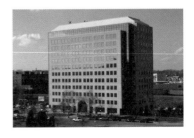

Andrew Johnson State Office Building, 710 James Robertson Parkway.

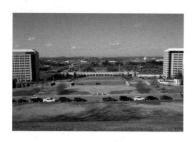

The Belvedere overlooking Bicentennial Mall State Park.

Archives on its eastern side. The Mall was designed by Tuck Hinton Architects. The eastern side has a simulation of the topography and plant life found across the state. On the walkway on Fifth Avenue North there is a series of time capsules from each of the ninety-five counties in Tennessee, with information about each county on the capstone. The south end of the Mall has a large granite map of the state, with the rivers and interstate highways marked out, as well as all of the county seats, which have lights beneath them so they are illuminated at night. A pair of ceremonial arches holds up a train track and a steel archway leading into the Mall. A large fountain representing all of the rivers of the state is a popular place with children on a hot day. Beyond it is a sunken amphitheater and the broad lawn of the Mall. On the western side is a set of cenotaphs counting out a timeline of history and a black granite wall with inscriptions about the history of the state as the timeline moves toward the present day. The Davidson County Farmer's Market is located on the western side of the Mall. At the north end is a carillon with ninety-five bells in it, one for each county in the state. A memorial to the music of Tennessee and its musicians is around the carillon.

84. CHARLES WARTERFIELD RELIQUARY, NORTHWEST CORNER OF CAPITOL HILL PARKING ROAD

On the northwest curve of the drive around Capitol Hill is an artfully arranged grouping of fragments from the original columns of the Tennessee State Capitol. When workers were repairing the deteriorating building in the 1950s, all of its original columns were removed. For the bicentennial of the state and the completion of the Mall, Charles Warterfield, one of the architects who had worked on that renovation and on the 1990s restoration, selected these pieces and placed them on the hill. When he died a few years later, this was named the Charles Warterfield Reliquary in his honor.

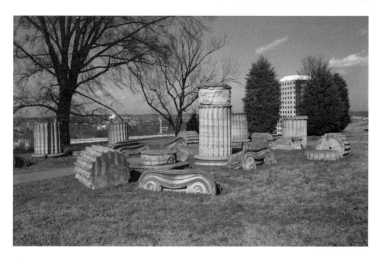

Charles Warterfield Reliquary, northwest corner of Capitol Hill parking road.

85. Tennessee State Library and Archives, 403 Seventh Avenue

Tennessee State Library and Archives, 403 Seventh Avenue North.

The Tennessee State Library and Archives is the state's official World War II memorial, and you see that inscribed above the door and in the service insignia in the grills in the lobby. This is the repository of Tennessee's documentary history. It was built in 1952 and 1953 by Clinton Parrent. The marble in the lobby contains many cephalopod fossils, and the terrazzo floor contains a map of Tennessee. The Tennessee Supreme Court plans to demolish the stacks at the rear and turn this building into a new wing of the Supreme Court Building next door when the Tennessee State Library and Archives moves to the Mall.

86. Tennessee Supreme Court Building, 401 Seventh Avenue

The Tennessee Supreme Court Building was built in 1937 and designed by Marr and Holman. The court got its own building at about the same time that the U.S. Supreme Court did. Both courts had been housed in the capitol buildings until the 1930s.

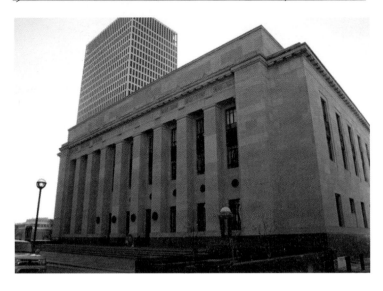

Tennessee Supreme Court Building, 401 Seventh Avenue North.

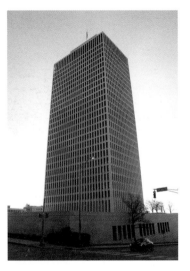

Tennessee Tower, between Eighth Avenue North and Seventh Avenue North.

87. Tennessee Tower, between Seventh and Eighth Avenues

The Tennessee Tower was built as the headquarters for National Life and Accident Insurance Company in 1969–70. It was designed by Skidmore, Owings & Merrill of Chicago. Today it is a state office building. It was to have had a twin tower at the southeast corner of the block, where the old National Life Building had been demolished. It is clad in travertine marble.

88. Hyatt Regency Hotel/Sheraton Hotel, 623 Union Street

The Sheraton Hotel was built in 1975 and is reminiscent of John Portman's Regency Hyatt Hotel in Atlanta. It was, in fact, a Hyatt Hotel when it opened. The Polaris Room at the top has one of the best views of downtown, and the floor revolves. The Polaris is only open for special rental functions.

89. JAMES K. POLK STATE OFFICE BUILDING AND CULTURAL COMPLEX, 505 DEADERICK STREET

90. RACHEL JACKSON STATE OFFICE BUILDING, 436 SIXTH AVENUE

91. ANDREW JACKSON STATE OFFICE BUILDING, 500 DEADERICK STREET

92. CITIZENS PLAZA BUILDING, 401 CHARLOTTE AVENUE

Hyatt Regency Hotel/Sheraton Hotel, 623 Union Street.

James K. Polk State Office Building and Cultural Complex, 505 Deaderick Street. Rachel Jackson State Office Building, 436 Sixth Avenue North. Andrew Jackson State Office Building, 500 Deaderick Street. Citizens Plaza Building, 401 Charlotte Avenue.

Deaderick Street is lined with state office buildings. To the right is the James K. Polk State Office Building and Cultural Complex, or the Polk Center. It has seventeen floors of offices suspended by steel girders above the Tennessee State Museum, which is housed in 120,000 square feet of space devoted to Tennessee's past, from prehistory to modern times. The exhibits currently only go up to the end of the nineteenth century. But gallery space is devoted to paintings, silver, ceramics, textiles, firearms and such figures as Daniel Boone, David Crockett, Sam Houston, Andrew Jackson, James K. Polk, Andrew Johnson, Nathan Bedford Forrest and John Hunt Morgan. The Tennessee Performing Arts Center is also in the building, and hosts concerts, ballets, plays and a Broadway series. The architects of the Polk Center were Taylor & Crabtree, and it opened in 1980. Earl Swennson Associates redid the northwest corner of the building.

At the opposite side of the street are the Rachel Jackson, Andrew Jackson and the Citizens Plaza State Office Buildings.

Rachel Jackson and Andrew Jackson were both designed by Taylor & Crabtree. Rachel Jackson opened in 1985 and Andrew Jackson in 1971. Citizens Plaza was designed by Earl Swennson Associates and opened in 1985.

Nashville Driving Tours

Tour Seven
Music Row and Music City

The music industry has a long history in Nashville. The *Western Harmony*, an early hymnbook, was published here in 1824. With the Southern Methodist Episcopal Church, the Southern Baptists, National Baptists, Cumberland Presbyterian Church and Churches of Christ all operating printing plants in Nashville, the city became known as the Buckle of the Bible Belt and became a printing center. Thomas Nelson and the Southwestern Company also do religious publishing here.

In 1925, the National Life and Accident Insurance Company launched a new radio station with the call letters WSM. They saw radio as a way to advertise their company and to promote their product, as WSM was branding for them—it stands for the company motto, "We Shield Millions." Using the auditorium in the company's new building on Seventh Avenue North as their studio space, they had a 1,000-watt clear channel station. With only one other station in the South as strong, WSM was stronger than 85 percent of all others in the country. This was a national marketing tool for the insurance company, as they could broadcast coast to coast.

WSM broadcast classical and popular music and included a quintet from Fisk University in its early programming. George Hay was hired from WLS, the Sears station in Chicago, as the announcer for WSM. On November 28, 1925, Hay tried a barn dance format program, with Uncle Jimmy Thompson performing for one hour on his fiddle. It was a big hit. So on December 26, 1925, the station launched an old-time music broadcast every Saturday night. Hay named the program *The Grand Ole Opry* in 1927 and continued to expand it. In 1934, the show had outgrown the insurance company office building as a performance space because so many people wanted to sit in the audience. So the show was moved to the Hillsboro

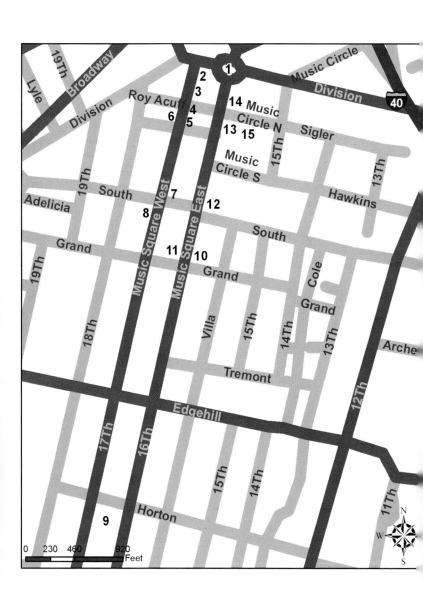

Theater, now known as the Belcourt Theatre. It remained there until 1936.

From 1936 to 1939, the program was held in the Dixie Gospel Tabernacle, a revival hall located at 408 Fatherland Street, in East Nashville. Then, still expanding its audience by giving free tickets to customers, the show moved to the War Memorial Auditorium from 1939 to 1943. In 1943, it moved again to the Ryman Auditorium and it became "The Mother Church of Country Music" until it moved to the new Grand Ole Opry House in 1974.

In 1938, Roy Acuff became a member of the Grand Ole Opry and was a nationally known recording star. In 1933, Fred Rose had moved to Nashville from Chicago to work at WSM. He met Roy Acuff, and in 1942 they opened Acuff Rose Publishing Company. It was the first successful music business in Nashville affiliated with the Grand Ole Opry.

In 1950, Chet Atkins was offered his first contract with RCA. He returned to Nashville and had a long studio career with RCA, beginning in 1952, when he was named assistant to Steve Sholes. He managed the new studio that RCA built in 1957. Sholes turned over the country music production work to Atkins, and the label did so well that Atkins was made a vice-president. He broadened the sound dynamics of country music and helped to create the Nashville sound.

Owen Bradley began working for WSM in 1935, and by 1948 was their musical director. He started working for Decca Records while with WSM, and in 1958 opened Decca's Nashville division. When Decca and MCA merged in the 1960s, he continued on. Working with such artists as Patsy Cline, he too worked to expand the Nashville sound like his rival at RCA, Chet Atkins, was doing. Buying a house on Sixteenth Avenue South with his brother Harold in 1954, they used an attached Quonset hut as a recording studio. This was the beginning of Music Row. Marty Robbins recorded *El Paso* and Patsy Cline recorded *I Fall to Pieces* there. Columbia Records bought the studio in 1962. The Bradleys then built Bradley's Barn in Wilson County as a new recording studio. In 1988, k.d. lang recorded *Shadowland* there.

Frances Preston went to work for Broadcast Music Inc. in 1955. She went on to become the worldwide president and CEO of the organization. Under her leadership, BMI for the first time protected the rights of country artists to the works that they had created.

Fred Rose, Roy Acuff, Chet Atkins, Owen and Harold Bradley and Frances Preston. These are the names of those who created Music City U.S.A. Take some time now to park your car and walk around Music Row. Studio B—where Chet Atkins recorded the music of Elvis Presley—Owen Bradley Park and all of the studios and organizations that have made Nashville

home to one of the most distinctive musical genres of America are worth exploring. Use the following locations as your guide.

Belcourt Theatre, 2102 Belcourt Avenue

Belcourt Theatre, 2102 Belcourt Avenue.

The Belcourt Theatre was the home of the Grand Ole Opry from 1934 to 1936. Built in 1925 as a silent movie theater, it also housed the Children's Theatre of Nashville, the longest running theater of its kind in the country, and the Actor's Guild. The Opry established its present format here, with two separate performances each Friday and Saturday night.

Acuff Rose Publishing Company, 2510 Franklin Road

The Acuff Rose Publishing Company Building was the last home to the publishing company founded in 1942 by Roy Acuff and Fred Rose. They published such performers as Hank Williams Sr., Roy Orbison, the Everly Brothers, Don Gibson and Tom T. Hall. Acuff Rose was the first country music publisher in Nashville, and released such hits as "Oh Pretty Woman," "Walkin' After Midnight," "Tennessee Waltz," "Your Cheatin' Heart" and "Cathy's Clown."

Acuff Rose Publishing Company, 2510 Franklin Road.

Dolly Parton Offices, 2401 Twelfth Avenue South

Dolly Parton has an office in a Mexican hacienda–inspired building.

Dolly Parton offices, 2401 Twelfth Avenue South.

1. *Musica* and Owen Bradley Statues at the Music City Roundabout, intersection of Division Street, Music Square East and Demonbreun Street

In the center of the Music City Roundabout is a monumental statue by Alan LeQuire, entitled *Musica*. It depicts people joyously dancing. In the adjoining park is another statue of Owen Bradley, the man who bought a Quonset hut and made it into the first recording studio in Nashville. He was a pioneer in the music industry here.

Above: Owen Bradley statue, Music City Roundabout.

Right: Musica by Alan LeQuire, Music City Roundabout.

2. American Society of Composers, Authors & Publishers, 2 Music Square West

ASCAP, the American Society of Composers, Authors & Publishers, is a music licensing business.

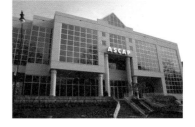

American Society of Composers, Authors & Publishers, 2 Music Square West.

3. Sony Music Publishing, 8 Music Square West

Sony Music Publishing has published such writers and artists as Bill Anderson, Gretchen Wilson, Harlan Howard, Marcus

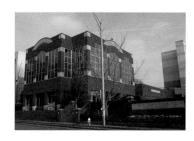

Sony Music Publishing, 8 Music Square West.

Hummon, Rodney Crowell, Taylor Swift, Buck Owens, Kenny Chesney, Brooks & Dunn, Merle Haggard and Rascal Flatts.

4. RCA Studio B, 1611 Roy Acuff Place

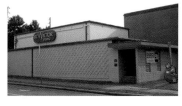

RCA Studio B, 1611 Roy Acuff Place.

RCA Studio B is where Elvis Presley, "The King of Rock and Roll," recorded over two hundred hits. It opened in 1957 and has been restored by the Country Music Hall of Fame and Museum; it is open for tours. This is where the Everly Brothers, Roy Orbison, Charlie Pride, Willie Nelson, Dolly Parton and LeAnn Rimes have all recorded.

5. RCA, Nashville, 30 Music Square West

RCA, Nashville, 30 Music Square West.

The former Nashville headquarters of RCA was opened by Chet Atkins as he built up the Nashville sound in the 1960s. Known as Mister Guitar, the Country Gentleman and Certified Guitar Picker, he propelled such stars as Dottie West, Waylon Jennings, Bobby Bare, Porter Wagoner, Dolly Parton, Jim Reeves, Jerry Reed, Skeeter Davis, Charley Pride and Eddy Arnold. Atkins was the most recorded solo instrumentalist in recording history. His style influenced such artists as the Ventures, George Harrison and Mark Knopfler.

6. Word Entertainment, 25 Music Square West

Word Entertainment was founded in 1951 and currently has more than forty thousand copyrighted gospel songs and around forty-five Christian songwriters under contract. Amy Grant is one of their recording artists.

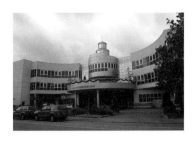

Word Entertainment, 25 Music Square West.

7. Starstruck Entertainment, 40 Music Square West

Starstruck Entertainment is Reba McEntire's production and promotion company. Recently it signed Kelly Clarkson.

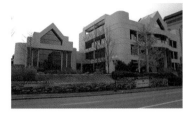

Starstruck Entertainment, 40 Music Square West.

8. Great American Country, 49 Music Square West

GAC, Great American Country, is a television station that exclusively promotes and reports on country music artists and events.

Great American Country, 49 Music Square West.

9. Sony BMG, 1400 Eighteenth Avenue South

Sony BMG is located in a former hospice and convent. It has under contract such artists as Alan Jackson, Brad Paisley, Kenny Chesney, Carrie Underwood, Sara Evans, Gretchen Wilson, Brooks & Dunn, Terri Clark, Montgomery Gentry and Martina McBride.

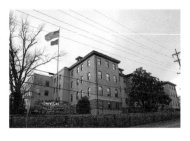

Sony BMG, 1400 Eighteenth Avenue South.

10. Universal Music Group, 60 Music Square East

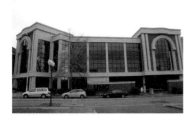

Universal Music Group, 60 Music Square East.

UMG, Universal Music Group, holds the catalogues to Mercury Records Nashville and Lost Highway Records, as well as continuing to recruit new talent. Its recording stars include Johnny Cash, Elvis Costello, the Eagles, Lyle Lovett, Hank Williams, Vince Gill, Chely Wright, Mark Chesnutt, Lee Ann Womack, George Strait, Reba McEntire and Josh Turner.

11. Society of European Stage Authors and Composers, 55 Music Square East

Society of European Stage Authors and Composers, 55 Music Square East.

SESAC, Society of European Stage Authors and Composers, is a performing rights organization with headquarters here in Nashville, and offices in New York, Los Angeles, Atlanta and London. It represents songwriters and publishers and their rights to be compensated for having their music performed in public. SESAC was formed in 1930.

12. Curb Records, 48 Music Square East

Curb Records, 48 Music Square East.

Curb Records represents such artists as the Judds, Bellamy Brothers, Hal Ketchum, Sawyer Brown, Ray Stevens, Jo Dee Messina, Tim McGraw, Ronnie McDowell, Hank Williams Jr., Wynonna Judd and Clay Walker.

13. Warner/Chappell, 20 Music Square East

Warner/Chappell represents such artists as Garth Brooks, Dwight Yoakum, Faith Hill, Trace Adkins, Trick Pony, Trisha Yearwood, Keith Urban, LeAnn Rimes and Shedaisy.

Warner/Chappell, 20 Music Square East.

14. Broadcast Music Inc., 10 Music Square East

BMI, Broadcast Music Inc., represents songwriters, composers and publishers with the collection of royalties that was founded by Frances Preston. She built this licensing business into its present powerful concern.

Broadcast Music Inc., 10 Music Square East.

15. Nashville Association of Musicians, Local 257, 11 Music Square North

Nashville Association of Musicians, Local 257 American Federation of Musicians, is the local musicians' union.

Nashville Association of Musicians, Local 257, 11 Music Square North.

Tour Eight
The Battle of Nashville

Nashville was the first Confederate state capital to be conquered by the United States Army, falling February 25, 1862, when Don Carlos Buell's troops first entered the city. The city remained under occupation for the duration of the war. But the city saw great change as a result of that. Most of the large businesses, churches, schools and factories were converted to war uses. A network of over twenty hospitals was set up in a large number of buildings, and they saw a huge influx of sick, wounded and dying men shipped into the city. In one day of fighting at Murfreesboro, or Stones River, over nine thousand wounded soldiers were shipped by rail into Nashville. Railroads became a military asset for the prosecution of the war effort. The U.S. government seized every railroad in Tennessee and formed a consolidated U.S. Military Railroad. It was used to ship troops into the field, to take the wounded behind the lines for treatment and to receive and ship out war goods. This necessitated tearing down the rail repair shop in Nashville and building a larger one. This was the first war to have battlefield treatment of wounded troops in field hospitals, which happened for the first time, in Tennessee, at Shiloh.

With warehouses full of war material, hospitals filled with ill and dying troops and a garrison of around seventy thousand troops at its peak, Nashville had to have defensive positions put up on its southern approaches. The U.S. government did not see African Americans as anything other than property at the outbreak of the war. So when slaves escaped from their masters and bondage and came to within the lines of Federal troops, they thought that they would be free. The government saw them as seized property, or contraband, and put them into forced labor gangs. These forced labor gangs were impressed

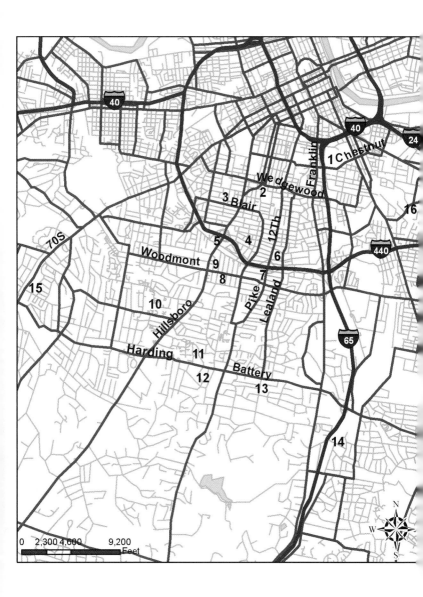

into service to build a series of forts around the southern edges of the city. Fort Negley is the largest stone fortress ever built on the interior of the United States. It was placed on St. Cloud Hill, a prewar wooded hilltop much favored for picnics due to its commanding view of the city. Fort Morton, a siege fort, and Fort Casino, atop Kirkpatrick Hill, were put up nearby. Each was on a commanding hilltop along the Franklin Turnpike leading into town. About where ASCAP is today was the site of Fort Houston, named for a Union sympathizer whose property was taken from him for the erection of a fort. Fort Gillem was built where the Fisk University campus is now. These forts ringed the southern approach and guarded Nashville's flanks.

By the summer of 1864, Atlanta was lost to the Confederacy, and John Bell Hood led the Army of Tennessee out of that debacle and hit upon the notion to move against Nashville in an attempt to draw Sherman out of Georgia. Sherman detached John Schofield to Nashville to reinforce the garrison there, while Sherman headed for Savannah and the Atlantic. Schofield and Hood raced each other back north. At Franklin, Hood caught up with his former classmate from West Point. This was an interesting encounter, for Schofield had helped Hood, who was about to be flunked out of the academy, study hard enough to graduate. At Franklin the old friends had become armed enemies. Hood ordered an open charge across nearly two miles of open fields against entrenched Federal troops. It was a bloodbath, with seven thousand casualties in the Confederate ranks. There were six Confederate generals killed, five wounded and one captured. But Hood pressed on to Nashville.

With a garrison of effective troops at about fifty-four thousand, General George Thomas had well over twice the troops at his command as Hood. Tennessee is prone to ice storms in the winter, and one hit Nashville around the second week of December, as the two armies faced each other on the fields south of town. Grant and Halleck were going crazy up in Washington, not knowing why Thomas was not attacking Hood. Finally, on December 13 a thaw set in, and Thomas called his staff together for a war council. Union troops led by James Steedman moved against Benjamin Franklin Cheatham on the morning of December 15. Steedman attacked from the Union left against the Confederate right. This attack had U.S. Colored Troops leading the way. On the west, Confederate General A.P. Stewart took the main blow of the assault. Outnumbered ten to one, the Confederate line rolled back on the west as the Union cavalry and infantry advanced. That ended the first day of fighting.

On December 16, the Confederates were found to have pulled back to the ring of hills running from the Hillsboro Turnpike to the Franklin Turnpike. They had entrenched in redoubts and trenches paralleling Hillsboro Pike and then positioned themselves atop Shy's Hill, along a rock fence running west to east, and then again atop Peach Orchard Hill at the Overton plantation, Travelers Rest. Again U.S. Colored Troops led the assault on the western end, while Minnesota troops led the main thrust from the west. Shy's Hill was taken, in large part because the trenches at the top were not at the military crest of the hill, but rather at the geographical crest. That meant that the defenders could not see to the bottom of the hill. They had dug the trenches in the middle of the night, and could not see their mistake until it was too late. With the collapse of the left flank, the Confederate lines failed. First came Stewarts Corp along the rock fence, and then the troops moved onto Peach Orchard Hill, where Stephen Dill Lee held the line until the Confederates could flee to the south along the Franklin Pike.

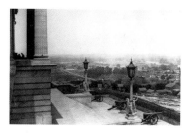

The Tennessee State Capitol. This 1864 photograph was taken by George Barnard for the U.S. government. *Courtesy of the National Archives.*

THE TENNESSEE STATE CAPITOL, SIXTH AVENUE NORTH AT CHARLOTTE AVENUE

The Tennessee State Capitol became Fort Andrew Johnson during the Union occupation. During the war, the capitol was fortified with earthworks, log palisades and a troop encampment.

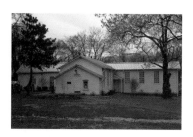

The Little Theater, Seventeenth Avenue North near Jefferson Street.

FISK UNIVERSITY LITTLE THEATER, SEVENTEENTH AVENUE NORTH NEAR JEFFERSON STREET

The Fisk University Little Theater was originally a Union barracks and was moved here when the university was founded. African Americans settled around Union troop encampments, and those

encampments led to the formation of the first African American neighborhoods that developed in Nashville. Many such present-day neighborhoods can trace their origins to Federal forts and camps.

FEDERAL HOSPITAL NO. 3, 219–224 BROADWAY

Now housing Ernest Tubb Record Shop and other businesses, this was the location of William Stockell's ornamental plaster and terra cotta business. He had done the ornamental plaster work in the Union Bank, the state capitol and Belmont prior to the war. During the occupation, this building was used as Hospital No. 3 in the Federal hospital system set up for the duration of the war. It had 250 beds in it.

Federal Hospital No.3, 219–224 Broadway. This is a George Barnard photograph from 1864. *Courtesy of the National Archives.*

THE DOWNTOWN PRESBYTERIAN CHURCH, 154 FIFTH AVENUE NORTH

The Downtown Presbyterian Church was part of Hospital No. 8. It contained 206 beds for the sick and wounded. Recently, ink bottles were found beneath the building that had been used by dying or wounded men for what would perhaps be their last letters home, and by doctors and nurses keeping a record of their treatment. A hair oil bottle was also found. Perhaps one of the men was a dandy.

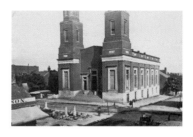

The former First Presbyterian Church, 154 Fifth Avenue North, was photographed in 1864 by George Barnard as a part of Federal Hospital No. 8. *Courtesy of the National Archives.*

The University of Nashville Literary Department Building, behind 800 Second Avenue South

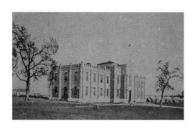

The University of Nashville's Literary Department Building, now behind 800 Second Avenue South. George Barnard took this photo in 1864. *Courtesy of the National Archives.*

The University of Nashville's Literary Department building was erected in 1854 at a cost of $45,000, which nearly bankrupted the school. During the war it was part of Hospital No. 2 and had three hundred beds. It stands behind Howard School.

1. Fort Negley Visitor Center, 534 Chestnut Street

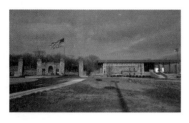

Fort Negley Visitor Center, 534 Chestnut Street.

Fort Negley Visitor Center is a new facility, opening in 2007. It includes interactive monitors for learning about the Civil War in Nashville and about Fort Negley. A cannon salvo from here is reputed to have signaled the start of the Battle of Nashville on December 15, 1864. The Public Works Administration rebuilt Fort Negley in the 1930s with a circular drive, a visitors' center in the fort and reconstructed walls, gun emplacements and a palisaded bastion with period guns. The city let it fall into ruin during World War II, and the hill became reforested and forgotten until Mayor Bill Purcell had it stabilized and built a new visitors' center.

Ruins of Fort Negley, behind Fort Negley Visitor Center

The ruins of the stone fort are still very impressive, with their loop holes for rifles and cannon and their massive walls. Take Chestnut Street to Eighth Avenue, turn left onto Eighth and go south toward Wedgewood Avenue. On the right after you make the turn is Kirkpatrick hill, the location of Fort Casino, another Union fortification. The hill is now the site of the 1880 City Reservoir, built from the original stone from Fort Negley.

Above: and Ruins of Fort Negley, which stand behind the Fort Negley Visitor Center.

2. Belmont Mansion, 1900 Belmont Boulevard

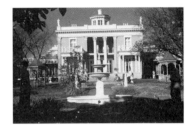

Belmont Mansion, located on the campus of Belmont University along Wedgewood Avenue, was used to billet officers prior to the battle, and General T.J. Wood had it as his command post. It is open to the public. The gardens here were the most elaborate ones in the state prior to the war, which caused some soldiers to say that it looked like a first-class cemetery. That was the only comparison many people had then to so many ornamental plants, statues, buildings and cast-iron pavilions.

Belmont Mansion, behind 1900 Belmont Boulevard.

 Adelicia Acklen had begun putting together land for this house, located near her father's and her sister's homes, around 1849. It was meant to be her twenty-thousand-square-foot summer home. She and Joseph Acklen, her second husband, moved here from Louisiana to escape some of the heat of the summer. At Belmont she built a substantial house with the largest formally landscaped gardens in the state. The gardens had marble and cast-iron fountains, marble and cast-iron statues, a rose maze, five cast-iron gazebos, a zoo, an aviary, a two-story bear house, a large greenhouse, a five-story water tower, two stables, an art gallery, a bowling alley and a pond. Originally named Belle Monte for Portia's home in Shakespeare's *Merchant of Venice*, it was to resemble an Italian estate. Adolphus Heiman, a Prussian architect who lived in Nashville, designed the house. It had balancing wings to the east and west, with cast-iron balconies on the three outer sides of those wings. To the north it had two wings projecting back toward Nashville. All of this sat upon 175 acres. In Louisiana, Adelicia owned seven plantations and

750 slaves. At Fairvue Plantation in nearby Sumner County, she owned 2,000 acres.

Adelicia learned from Joseph that the Confederates had ordered the burning of 2,800 bales of cotton from her Louisiana plantations in order to keep it from the hands of the Union army. Joseph died suddenly, and Adelicia raced to Louisiana to negotiate with both armies to safeguard her cotton. She got the cotton to Mississippi, where the Confederates, suspecting her motives, arrested her and seized the cotton again. She talked her way out of that situation, and got Union naval vessels to take her cotton to New Orleans. There she shipped her cotton to England, and the Rothschilds paid $960,000 for it. She returned to Nashville from New Orleans via New York City and found Belmont quartering Union troops. The city was besieged from the south by the Army of Tennessee under the command of John Bell Hood, and her art collections had been shipped into the city and stored at Mrs. Polk's home for safekeeping. After all, U.S. troops would not steal from a former first lady.

Following the war, Adelicia married again. But before she did so, she took a trip to Europe, visited artists, met Napoleon III and Eugenie and shipped statues, paintings, china and other things home to Belmont. In 1867, she sent out 1,200 wedding invitations and married William Archer Cheatham on a night with a full moon, in order to party in the gardens of Belmont until dawn. She died in 1887 while shopping in New York City.

3. GLENOAK, 2012 TWENTY-FIFTH AVENUE SOUTH

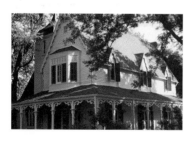

Glenoak, 2012 Twenty-Fifth Avenue South.

Glenoak was built between 1854 and 1857 by Charles Tomes, rector of Christ Church and later of Church of the Advent. He owned fifteen acres along the Hillsboro turnpike. Tomes was born in England in 1814 and had come to this country as an infant. He was educated in New York City. He came to Nashville after his first wife's death and some business reverses. At that time, he wished to study to become an Episcopal priest, so he lived in the home of Bishop James Hervey Otey. There he met the bishop's daughter, Henrietta, and married her. They lived at Glenoak. Tomes died at age forty-seven in 1857. His widow sold the house to Lizinka Brown, the daughter of George

Washington Campbell, and she later married Richard Stoddard Ewell. During the war the house was rented out, and Federal trench lines ran through the yard. In 1868, a banker, Edgar Jones, bought the house and his descendants lived in it until 1938. The Ralph Morrisseys lived there until the 1980s, when they sold it to Tom Ward, rector of Christ Church, Tomes's former pulpit. At the time of the Battle of Nashville it stood between the lines. It is one of the finest Gothic Revival homes in Middle Tennessee.

4. OUTBUILDING TO THE MONTGOMERY PLANTATION, 1806 CEDAR LANE

5. OVERSEERS HOUSE, BEHIND 2911 HILLSBORO ROAD

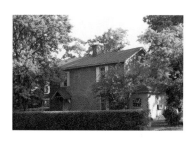

Montgomery Plantation outbuilding, 1806 Cedar Lane.

At Cedar Lane and Brightwood was about where Colonel A.B. Montgomery had his plantation house. The road is called Cedar Lane because the drive was lined with cedar trees. An advance Confederate skirmish line was here. At 1806 Cedar Lane is a surviving outbuilding from the plantation, perhaps a slave house. Another building from the Montgomery plantation is located at 2911Hillsboro Pike, behind the Christian Scientist Church. The rear of this house dates to around 1798, and the front to 1825.

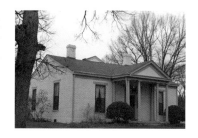

Montgomery Plantation overseer's house, behind 2911 Hillsboro Road.

6. SUNNYSIDE, 3000 GRANNY WHITE PIKE

Built in the 1840s, Sunnyside stood between the lines of battle and was used as a hospital after the fighting waned. The widow of Jessie Benton, the brother of Senator

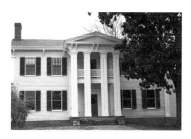

Sunnyside, 3000 Granny White Pike.

Thomas Hart Benton, lived here at the time of the Battle of Nashville. The Metro Historical Commission now has its offices in the house. The commission offers free brochures on historic sites in the Nashville area.

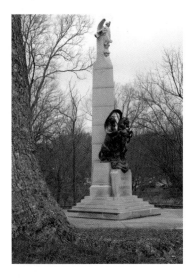

Battle of Nashville Peace Monument, Twelfth Avenue South at Battlefield Drive.

7. Nashville Peace Monument, Twelfth Avenue South, between Battlefield Drive and Clifton Lane

The Nashville Peace Monument commemorates the Battle of Nashville. It was originally erected on Franklin Road and was moved here in the 1990s. The bronze is original and is by Guiseppi Moretti, who was the sculptor of the Commodore Vanderbilt statue in front of Kirkland Hall at Vanderbilt University and of the statue of Vulcan in Birmingham.

Confederate trenches, 1811 Woodmont Boulevard.

8. Confederate Trenches, 1811 Woodmont Boulevard,

9. Redoubt No. 1, 3423 Benham

At 1811 Woodmont Boulevard, you will see Confederate trenches running through the front lawn of this private yard. Confederate Redoubt No. 1 is also located in this area. The remains of the earthworks are visible. They are marked by the Battle of Nashville Preservation Society and are open to the public. There are interpretive signs here.

Redoubt No. 1, 3423 Benham.

10. Confederate Redoubt No. 4, Abbottsford

Confederate Redoubt No. 4 in Abbottsford on Abbott Martin Road.

Continue west on Woodmont to Hillsboro Road and turn left. On the hill to your left was Redoubt No. 2. The remains of Redoubt No. 3 were destroyed in the 1980s by Calvary Methodist Church, which put a building on top of the clear remains of a site where men sacrificed their lives fighting. Redoubt No. 4 still exists in the Abbottsford development. The hill is at the back left of the development. The redoubt is preserved there and is marked.

Return to Hillsboro Road and turn right, heading south. As you pass Hobbs Road, a steep hill rises on your right. At the top of this hill was Redoubt No. 5. Across the road to the left was the Compton plantation, which served as a hospital for both armies. One of the casualties brought there was Colonel William Shy, who died defending the hill that was renamed in his honor.

11. Federal Trenches Facing Shy's Hill, Shy's Hill Road at Lone Oak

Federal trenches flanking Shy's Hill, Shy's Hill Road at Lone Oak.

Having been pushed back into a new defensive line following major reverses the first day of the battle, the Confederate forces regrouped along a new line the night of December 15. At the intersection of Shy's Hill Road and Lone Oak, the faint outlines of Federal trench lines are visible on the right.

12. The Top of Shy's Hill, Benton Smith Road

The left flank of the Confederate line was stationed here the second day of the Battle of Nashville. The hill has a pathway

The top of Shy's Hill.

Stewart's Corps used this rock fence as a defensive position. It is parallel to Battery Lane, and Lealand crosses it.

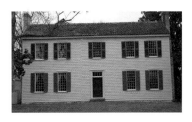

Travelers Rest, 636 Farrell Parkway.

up to its top and historical text panels, including a reproduced image of the Howard Pyle painting exhibited in the Minnesota State Capitol of the charge up the hill by Minnesota troops. They took the hill, largely because the entrenching was not done at the defensible military crest of the hill.

13. STONE WALL, BATTERY AND LEALAND LANES

Return to Harding Road and turn right. Take it to Granny White Pike and turn left onto Stonewall Drive. The stone wall that runs behind these homes to your left was the position held by Stewart's Corps, who used this rock fence as a defensive position on December 16, 1864. Continue on Stonewall until you get to Lealand Lane, then turn left. You will drive through the stone wall at this point and turn right on Battery Lane. This road was named for the Confederate artillery placed here during the battle.

14. TRAVELERS REST, 636 FARRELL PARKWAY

Take Battery Lane to Franklin Road. Across the intersection is Peach Orchard Hill; a Tennessee Historical Commission marker is to the left at the top of the hill. It was here that Stephen Dill Lee held the Confederate

right flank on the second day of fighting. His position had been repeatedly assaulted by U.S. Colored Troops, and after the battle the hill was blue with the fallen bodies of those men.

Travelers Rest was General Hood's headquarters before the Battle of Nashville. The site has interpretive panels that will tell you more about the battle. The house dates to 1799. The right side of the clapboard dwelling is the earliest portion. The left side was added later, as were two additions to the rear. It is open to the public.

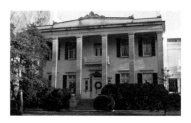

Belle Meade Plantation, 5025 Harding Road.

15. Belle Meade Plantation, 5025 Harding Road

Two other sites are of interest regarding the battlefield. Belle Meade Mansion was the home of John Harding and his son, William Giles Harding. The son had been born in the old Dunham cabin beside Richland Creek, and as the farm expanded and prospered they built a new two-story brick house, two rooms over two rooms. The farm continued its expansion under this only son, and by 1820 when the brick house went up it covered one thousand acres and was home to nearly fifty slaves.

Note the bullet-scarred columns.

Young William Giles Harding went to school at the American Literary and Scientific Academy in Connecticut in 1829. He married and had two sons while living on one of his father's holdings on the Stones River. That wife, Selene McNairy, died, and he moved back home to Belle Meade. In 1839, his father moved into town and gave his son the plantation to run himself. In 1840, he married Elizabeth McGavock and they had two daughters. By 1853 they had doubled the depth of the house by adding two more rooms over two others onto the central hall house. They also added a massive stone portico to their home. The shafts are made up of two pieces of quarried limestone each.

By this time the plantation covered four thousand acres. Various crops and livestock were raised there, and a four-hundred-acre deer park was created with herds of deer and buffalo.

With the coming of the war, state militia General Harding gave financial support to aid the Confederacy. When the city was conquered, he was arrested for having done this and was imprisoned at Fort Mackinac, Michigan. He was released after taking an oath of loyalty to the United States and returned to Belle Meade. During the Battle of Nashville, Chalmers Confederate forces were camped on the property and were driven off by the Federal maneuver that started at the Cumberland River and drove the Confederates back to the Hillsboro Pike. During this skirmish, General Harding's daughter Selene ran out onto the front porch and waved her handkerchief to the Confederate troops to encourage them. The front columns were pockmarked with Federal bullets as a result of this, and they still show the scars today.

In 1868, Selene Harding married former Confederate General William Hicks Jackson. He helped to run Belle Meade and eventually, after William Giles Harding died in 1886, Jackson was in sole charge of the plantation. Harding and Jackson built up the thoroughbred stud farm into the finest in the country. Such horses as Man of War, Iroquois, Citation and Seattle Slew are descended from that blood line. In 1903, the farm went bankrupt and the land was purchased to be developed into an exclusive neighborhood for the wealthy elite of Nashville. Today Belle Meade is open to the public.

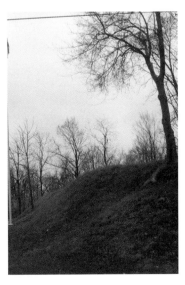

Granbury's Lunette.

The railroad cut.

16. Granbury's Lunette, 190 Polk Avenue

On the first day of fighting, Granbury's Lunette was held by General B.F. Cheatham and was assaulted by General Steedman's U.S. Colored Troops. The attackers got pinned down in the railroad cut and lost many men. They then retreated to the north and east. This site is located near the Tennessee State Fairgrounds. The Battle of Nashville Preservation Society has an interpretive panel here.

Tour Nine
Historic Neighborhoods

Nashville has quite a few historic neighborhoods, but the oldest are in east Nashville and north Nashville. Explore the streets in these two areas, as they have very good restaurants, and some interesting shops.

Historic East Nashville

Edgefield was a separate city from 1868 to 1880. There were several large country estates located in the area when the only way to reach it was by taking a ferry boat across the river. Dr. John Shelby was the first child born to settlers in Sumner County. He inherited his father's 640-acre tract across the Cumberland River from Nashville and built his large house on part of that tract, where Woodland Street is now. Nearby he built two homes for his daughters. Priscilla, Mrs. John Phelan, lived in Fatherland; and Anna, Mrs. Minnick Williams, lived in Boscobel. Fatherland was Italianate and had extensive grounds. It was torn down by the city in the 1950s for a very large public housing complex. A little farther out the Gallatin Pike was Edgewood, another Italianate two-story house with a cupola. It was the home of John Bransford.

By the 1850s, the area was being divided up for suburban homes. Governor Neil Brown lived in the area, and he named his community Edgefield, since it was at the edge of the Cumberland and there were fields along the riverbank. It was a very prosperous area for many decades. The 1870s, 1880s and 1890s saw a lot of development in homes, churches and shops. As the twentieth century dawned, prospects continued to look good for the area, and development moved farther out along Main Street and the Gallatin Pike. East End, Lockeland Springs and Maxwell Heights all saw a boom in housing construction.

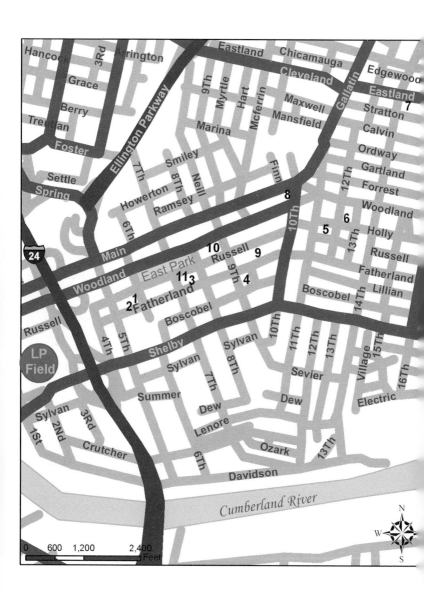

In March 1916, however, a great fire swept through Edgefield and destroyed 648 buildings. Following the fire, bungalows were put up where older homes had been lost. In 1933, a tornado hit the area and destroyed more property. During the Great Depression and World War II, people began to rent out rooms and to divide single-family homes. The area declined.

The 1960s were not kind to the area. The city ran an interstate highway through Edgefield and began demolishing the nineteenth-century homes and putting up tiny, and badly made, homes for lower-income people. By the 1970s, people were rediscovering the convenience of the area to downtown and began moving back. Historic Edgefield Inc., one of the first neighborhood groups in Nashville, was formed to promote the area and protect it from further government destruction. It became a National Register District and was the first Historic Zoning District in town. Today it is one of the premier historic neighborhoods in Nashville. The development has spread outward from Edgefield into East End, Lockeland Springs and Maxwell Heights.

1. *Tulip Street Methodist Church, 522 Russell Street*

Tulip Street Methodist Church, 522 Russell Street.

From the courthouse take Woodland Street Bridge across the Cumberland River to the east bank. Here you will see LP Field, home to the Tennessee Titans NFL team and to Tennessee State University's Tigers. Go out Woodland Street to South Fifth Street and turn right. You will see a large 1869 Italianate house with a tower ahead. Turn onto Russell Street, on the left, before you reach this home. Go to the end of this block, and on your right is Tulip Street Methodist Church. The exterior has a wonderful assortment of terra cotta ornamentation. Look up at the taller of the two towers and you can see a terra cotta dragon with spread wings holding up a balcony. There is a smaller version of this same dragon on the Brandon Printing Company building at 228 Second Avenue North. On the corner of this tower is the Archangel

Gabriel, holding his horn in his hands. In this tower are housed the Tennessee Centennial Exposition Carillon bells. They are still played.

2. *519 Fatherland Street*

519 Fatherland Street.

Behind Tulip Street Methodist Church is 519 Fatherland Street, one of several very colorful Victorian homes that you will see in this neighborhood.

3. *Jesse James House, 711 Fatherland Street*

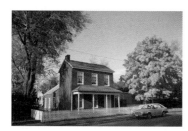

Jesse James House, 711 Fatherland Street.

Go up two blocks to 711 Fatherland Street. While he was hiding out from the law, Jesse James lived in this two-story Federal-style home with a one-story L at the back.

4. *910 Fatherland Street*

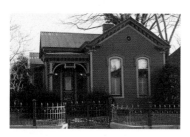

910 Fatherland Street.

Continue up the street to 910 Fatherland Street. This Victorian cottage has one of the most colorful paint combinations in the neighborhood.

5. *The Ambrose House, 122 South Twelfth Street*

The Ambrose house was the home of the owners of Ambrose Printing Company. It was designed by Hugh Cathcart Thompson in 1890.

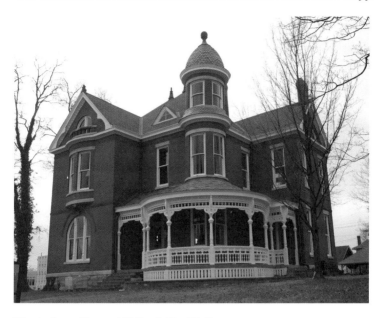

The Ambrose House, 122 South Twelfth Street.

6. HUGH CATHCART THOMPSON HOME, 1201 HOLLY STREET

Hugh Thompson's own home has a pressed tin roof and exuberant millwork.

7. 1405 STRATTON AVENUE

At 1405 Stratton is another fine example of Victorian architecture. One of the sons of Sergeant Alvin York once lived in this house. Sergeant York singlehandedly killed 25 Germans and captured 132 more in one engagement. He was declared America's greatest hero in World War I.

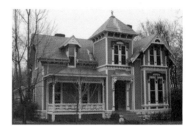

Hugh Cathcart Thompson House, 1201 Holly Street.

8. EAST BRANCH CARNEGIE LIBRARY, 206 GALLATIN ROAD

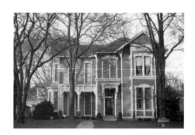

1405 Stratton Avenue.

Take a look around the neighborhood, then turn around and go to Gallatin Road.

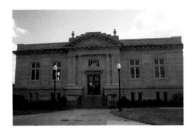

East Branch Carnegie Library, 206 Gallatin Road.

Turn left and head toward downtown. On your right you will see East High School, another Marr and Holman–designed building. To the left where South Eleventh and Gallatin Road come together is the East Branch of the Nashville Public Library. It was paid for through funds provided by Andrew Carnegie. It has been restored. The original cabinets and desks are in place, and the floor has been returned to cork flooring in order to muffle sound.

Turn left onto South Tenth and go back over to Russell Street. Turn right. This block has a good bit of infill. After the city destroyed most of this block in an "urban renewal" project, the neighborhood bought the land from the city over a decade later and hired a contractor to do sympathetic infill on the vacant lots. The unit at 930 A and B Russell won a Metro Historical Commission Award for design that complements the area.

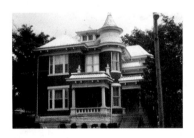

920 Russell Street.

9. *920 Russell Street*

At 920 Russell you can still see the stone paving blocks that lined the alleys of the neighborhood. The alley is now closed, and the owners of this house use it as a driveway. Notice the restored millwork on the balcony, and the tower. Also see the pressed tin on the roof.

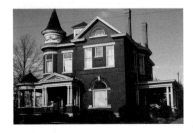

809 Russell Street.

10. *809 Russell Street*

The house at 809 Russell Street has a twin on Main Street in Franklin, Tennessee. Look at all of the stained glass in arched windows and the tops of several others.

HISTORIC NEIGHBORHOODS 135

11. *Edgefield Baptist Church, 700 Russell Street*

Take Russell Street back toward downtown. You will pass the former Russell Street Cumberland Presbyterian Church at the corner of Ninth and Russell. It has two beautiful rose windows. Unfortunately, a developer bought the church and kept all the rest of the stained glass. At 700 Russell Street is Edgefield Baptist Church. It was one hundred years old in 2007.

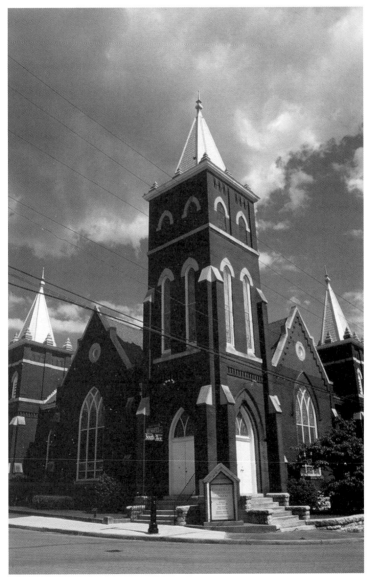

Edgefield Baptist Church, 700 Russell Street.

Historic North Nashville (Germantown)

North Nashville, like Edgefield, developed prior to the Civil War. The first European settler to be born here, Felix Robertson, the son of James and Charlotte Robertson, was born at Freeland's Station, a frontier blockhouse located at about 1400 Eighth Avenue North, near the Werthan Bag Company factory that is now loft condominiums. This birth took place on January 11, 1781. Felix would grow up to study medicine in Philadelphia and would return to Nashville as a doctor.

German immigrants began to settle in the area in the 1830s. Among them were John H. Buddeke and his wife Mary Ratterman. The rear of the house at 1229 Seventh Avenue North probably dates to that period. They added onto it in the 1850s, and the German Catholic congregation organized in their home and met there until Assumption Church was built between 1856 and 1859. Buddeke became very prosperous in selling whiskey and groceries, and his wife traveled to Europe and brought back items with which to decorate their home. Mr. Buddeke had Bishop Pius Miles as a guest when the bishop first arrived in Nashville. Bishop Miles went on to build the first cathedral in Tennessee, St. Mary's, which is now a parish church at Fifth Avenue North and Charlotte. It opened in 1847. The German Catholics wished to worship together, so they built a church of their own. Notable architect Adolphus Heiman built a home for himself at Ninth and Jefferson Street. Joseph Baltz and Henry and Lawrence Neuhoff were from meatpacking families who built packing plants in the area; the William Gerst family were brewers; and John Herman Buddeke was a grocer at 66 Market Street.

In 1871, Samuel Dold Morgan built a cotton mill where the David McGavock house had stood. McGavock had been the original landholder in the area. With the coming of industry to the area in the late nineteenth and early twentieth centuries, the population shifted to working class. By the 1950s, the area was in a downward spiral. Like in much of the country, however, the 1970s brought change. Urban pioneers began to move into the neighborhood, and prostitutes, drug dealers and other undesirables began to leave. Now the area is experiencing a building boom, with condominiums and town houses. The cotton mill is now lofts, and the area is home to several fine restaurants.

1. *Church of the Assumption, 1227 Seventh Avenue North*

The Church of the Assumption is at the heart of old Germantown. It was built between 1856 and 1859. The north wall is constructed of bricks salvaged from Holy Rosary Church

HISTORIC NEIGHBORHOODS 137

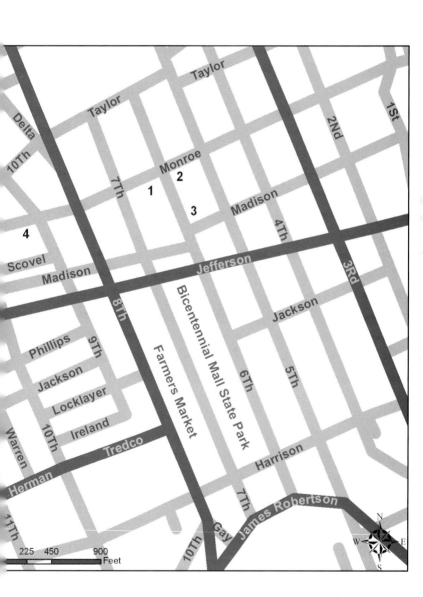

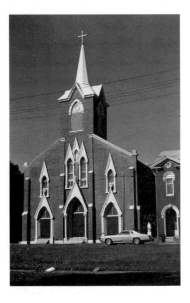

Left and above: Church of the Assumption, 1227 Seventh Avenue North.

on Capitol Hill, which was torn down about 1858 as the capitol grounds were expanded. One of the members of this church was named to the Roman Curia in 1958 by Pope Pius XII. Samuel A. Stritch was born three blocks from the church and went on to become the archbishop of Chicago.

2. *Buddeke House, 1226 Seventh Avenue North*

The Church of the Assumption was originally organized in the Buddeke house across the street from the current church. The front of the house was probably built in the mid-1850s.

HISTORIC NEIGHBORHOODS 139

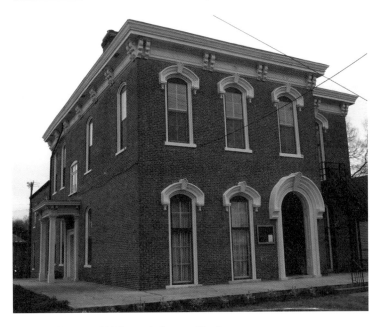

Buddeke House, 1226 Seventh Avenue North.

3. *1210 Seventh Avenue North*

The house at 1210 Seventh Avenue North has beautiful terra cotta lions' heads imbedded in the walls beside the second-floor windows to the right. It also has stone fan ornamentation above the windows.

4. *North Branch Carnegie Library, 1001 Monroe Street*

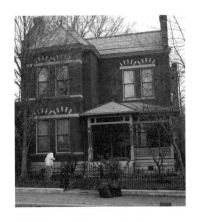

1210 Seventh Avenue North.

The North Branch of the Nashville Public Library is another Carnegie gift. It was designed in 1915 by C.K. Colley. Across the street is the former Third Baptist Church, now the Hopewell Baptist Church. It dates to 1907.

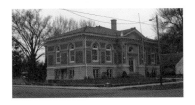

North Branch Carnegie Library, 1001 Monroe Street.

Tour Ten
Historic University Campuses

Higher education has a long and distinguished history in Nashville. Beginning with the University of Nashville and Shelby's Medical College in the antebellum period and continuing up to the present day, the city has prided itself on its educational opportunities. Prior to the Civil War, it was known as the "Athens of the West." Following the Civil War, the University of Nashville became the State Normal School, and when it obtained Peabody endowment funding, the George Peabody School of Teachers. The end of the war also brought several schools set up by philanthropic Northern groups to educate the newly freed African American population. American Baptist Home Mission Society established Roger Williams University, where the Peabody campus and part of Hillsboro Village are located now. Central Tennessee College, later to be called Meharry, was on Maple Street, south of Lafayette. Fisk University was on the site of Fort Gillem, along Jefferson Street. The state of Tennessee set up the University of Tennessee Medical and Dental Department on Broadway, between Sixth and Seventh Avenues North, on the north side along an alley. The Tennessee School for the Blind was built on the Lebanon Pike, next to what is now Rolling Mill Hill. Vanderbilt University was founded then as well. It was endowed by Commodore Cornelius Vanderbilt with $1 million. The Nashville College for Young Ladies was opened where the Federal Building stands now. Ward's Seminary, a school for young ladies, was on Eighth Avenue North, and Belmont College moved into Adelecia Acklen's home, Belmont. These two schools would later merge into Ward-Belmont, one of the South's finest finishing schools.

Later schools to come into fruition were David Lipscomb University, a Church of Christ–affiliated school; Trevecca Nazarene University, a Church of the Nazarene–affiliated school;

Belmont University; and Tennessee State University. Most of these schools still exist. Nashville has a large concentration of colleges and universities, making it a young and vibrant community.

Fisk University, Jefferson Street and Dr. D.B. Todd Boulevard

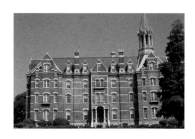

Jubilee Hall, Fisk University.

Jubilee Hall

Fisk University dates back to 1866, when it was founded by the American Missionary Association, the Freedman's Aid Commission and General Clinton B. Fisk of the Freedmen's Bureau. It was created in order to lift up newly liberated slaves through education, so that they could become productive citizens. Starting out in former Union army barracks, it began with the teaching of literacy. It was then named the Fisk School and it taught all grades from elementary to normal school as a training ground for teachers in the African American community. Chartered as a university in 1867, it struggled financially. By 1871, the Jubilee Singers were formed and went on tour in order to raise money for a building program for the school. George L. White was Fisk's treasurer and music teacher. He put together five women and four men as a trial tour group to raise money for the school. White selected the name Jubilee Singers after the year of jubilee, when the Jews were delivered from bondage (Leviticus 25). The group toured nationally and internationally, even singing before Queen Victoria. They raised $150,000, enough to repay the purchase price for the land that the university was on, and to pay for Jubilee Hall. That building was erected between 1873 and 1876. Stephen D. Hatch of New York designed it. The wainscoting in the front halls is made from wood brought from the Mendi Mission in West Africa. The newel post in the hall is made up of twenty-nine different kinds of fine woods. The front door is black walnut with bronze trim.

FISK CHAPEL

The Fisk Chapel was erected in 1892 and was designed by William Bigelow. It is used for graduation services, concerts and convocations.

CRAVATH MEMORIAL HALL

Cravath Memorial Hall was built in 1929-30 by Henry C. Hibbs. It is in his Collegiate Gothic style, which he also used at Rhodes College in Memphis and at Scarritt College in Nashville. The paneling in the reading rooms is beautiful.

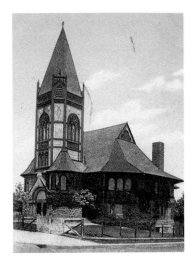

Fisk Chapel.

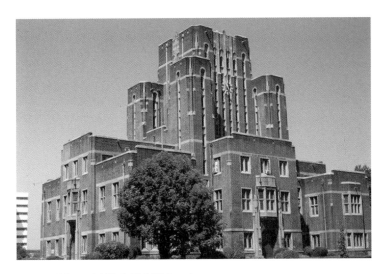

Cravath Memorial Hall, Fisk University.

AARON DOUGLAS MURAL IN CRAVATH MEMORIAL HALL

Aaron Douglas created a series of murals inside the reading rooms in 1930, which depict the enslavement of Africans, their shipment to the New World, their toils and trials in a new land and the rising up of their people in the Harlem Renaissance, in which Douglas played a part. He was the first African American to head the art department at Fisk.

Aaron Douglas mural in Cravath Memorial Hall, Fisk University.

VANDERBILT UNIVERSITY, TWENTY-FIRST AVENUE SOUTH AND WEST END AVENUE

KIRKLAND HALL

Kirkland Hall has been the administration building of Vanderbilt University since 1874–75. It originally had a chapel in the wing

to the rear, as Vanderbilt was founded as a Methodist school. Commodore Cornelius Vanderbilt was persuaded by Bishop Holland McTyeire to donate money to fund a university in the South for the Methodist Episcopal Church South. Through a family connection to Vanderbilt's second wife, McTyeire prevailed upon the commodore and got two gifts of $500,000 each. They were the only sizable gifts to charity that Vanderbilt ever made. Kirkland Hall was designed by William C. Smith. The building caught fire in 1905 and was remodeled with a single Siena-style tower, rather than the two French Gothic ones that it originally had.

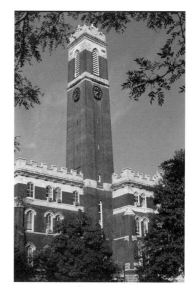

Kirkland Hall, Vanderbilt University.

Old Science Hall

The Old Science Hall was built in 1880 and was designed by Peter J. Williamson. Vanderbilt remained a Methodist-affiliated school until 1914, when it broke with the church over issues involving freedom from religious interference. The Methodist Church then founded Emory University in Decatur, Georgia. William K. Vanderbilt, following his father Cornelius's death, became a benefactor of the university. In 1879, he promised $100,000, which was later increased to $150,000, for the construction of Science Hall, the gymnasium and Wesley Hall, a large dormitory.

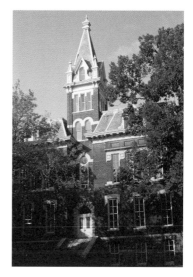

Old Science Hall, Vanderbilt University.

OLD GYM

Peter J. Williamson fought for the Union during the Civil War and moved to Nashville after the fighting ended. It was hoped that Vanderbilt could attract men from both North and South who would study together and help to reconcile the country. Williamson designed the Old Gym in 1880. When it was built, it was the best-equipped gym in the South. In 1962, the interior was remodeled for an art gallery and art classrooms.

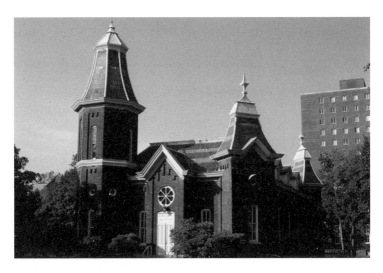

Old Gym, Vanderbilt University.

VANDERBILT UNIVERSITY COMPUTER CENTER

Vanderbilt University Computer Center.

The Vanderbilt Computer Center is part of the Stevenson Science Center, which was built between 1963 and 1974. It appears to be inspired by the round church at Temple Bar in London, a wonderful medieval structure. The Temple Bar Knight Templar Church, built in 1184, has the same profile as this building, which is round with a round projecting tower on top.

Scarritt College for Christian Workers, 1008 Nineteenth Avenue South

Now run by a Methodist women's group as a retreat and conference center, Scarritt was originally a Methodist church workers' school. Designed by Henry C. Hibbs in 1924, Fondren Hall and the Wightman Chapel are two of his finest Collegiate Gothic works.

George Peabody College for Teachers, Twenty-First Avenue South and Edgehill Avenue

Absorbed by Vanderbilt University in 1979, Peabody is now the College of Education for Vanderbilt. Henry C. Hibbs came to Nashville to help with the building of this campus. It is patterned after the University of Virginia, with a broad central lawn, a domed building at the top of a rise in the ground and academic buildings flanking the lawn.

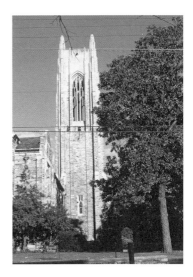

Scarritt College, 1008 Nineteenth Avenue South.

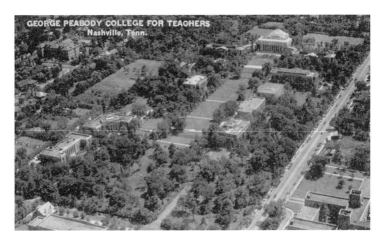

George Peabody College for Teachers around 1930.

Peabody Social and Religious Building

Peabody Social and Religious Building, around 1930.

The Social and Religious Building was designed by McKim, Mead and White in 1925. Graduation ceremonies were held on the lawn.

The Cohen Gallery

The Cohen Gallery was built to house the teaching collection of the college. In the 1960s, the department acquired the only part of the Kress Collection of Renaissance art in Nashville. With the development of a studio art program and the introduction of now such nationally known craft artists as Sylvia Hyman in ceramics and Michael Taylor in glass, the building was converted to studio space. Vanderbilt is looking toward making it back into an exhibition gallery for the only comprehensive art collection in Nashville, which is the study collection of Peabody and Vanderbilt.

The Cohen Gallery, Peabody Campus.

Belmont University, 1900 Belmont Boulevard.

BELMONT UNIVERSITY, 1900 BELMONT BOULEVARD

Founded as a private girls' college in 1890, the school merged in 1913 with the Presbyterian girls' school Ward Seminary. Taking the name Ward-Belmont, it operated until 1951. Such women as Clare Booth Luce, Mary Martin and Ophelia Colley Cannon (better known as Minnie Pearl) all graduated from there. Founders, Friendship and Fidelity Halls all were built to the rear of Belmont Mansion and face downtown Nashville. They date to the early years of Ward-Belmont. In 1951, the Tennessee Baptist Convention bought the school and ran it until 2007. Now it is an independent school, with no direct church control. The Jack C. Massey Business Center (1990) and the new School of Nursing (2007) are two new buildings added on in the same general style, making a harmonious blending.

Tour Eleven
Historic Cemeteries

OLD CITY CEMETERY, FOURTH AVENUE SOUTH AT OAK STREET

Established in 1822, it is the oldest surviving cemetery in Nashville. Two earlier ones were closed, and the burials were relocated. There have been around twenty thousand interments here. As it is the oldest surviving cemetery in the city, it is here that some of the earliest residents' graves can be found. When it opened in 1822, there was no racial segregation under Tennessee's 1796 constitution, so black and white people were intermingled in burial. Segregation came about after the Nat Turner Rebellion in Virginia caused a change in the new constitution of 1834, which limited the rights of free blacks. With the opening of Mount Olivet in 1856, City Cemetery began to fall into disuse. In 1878, it was closed to sales of vacant lots. The cemetery had a wooden fence around it originally, but in 1889 a wire fence was erected. In 1911, the Women's Federation of South Nashville and the Women's Historical Association of Tennessee erected a memorial gate at the Fifth Avenue entrance. In 1912, a stone fence was erected on two sides of the property. In 1946, Edwin Keeble was contracted to erect an office building in the center of the cemetery. In 1958, monuments were reset and re-lettered, a mile of ten-foot-wide roads was paved, thirty-one light poles were installed and plantings were made. In 2007, $3 million was appropriated to again clean monuments, restore them, trim and remove some trees, improve the roads and lighting and fence in the remaining boundary of the cemetery.

1. *WALKER MONUMENT*

The Walker Monument is to your left as you enter the cemetery, located in section 5. Sarah Ann Gray Walker died at age twenty-

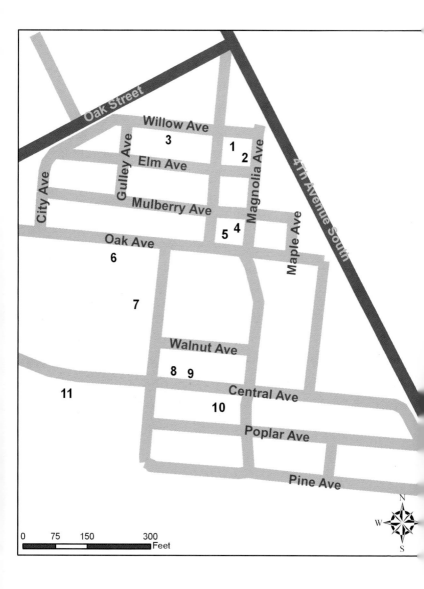

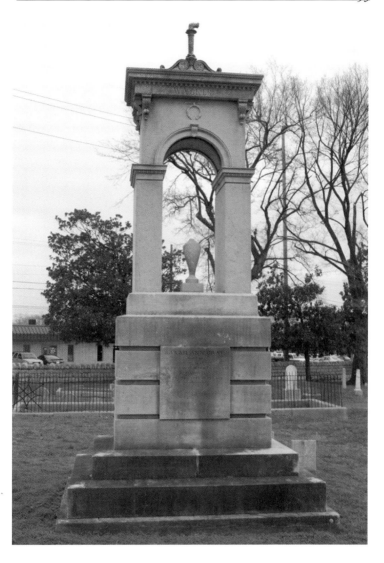

Walker Monument.

eight, and her grief-stricken husband erected this monument to her. Prominent architect William Strickland designed it, and his name is carved into the base at the lower left. The urn is a symbolic catchment for tears shed by the mourner, and the burning torch carved at the top refers to immortality.

2. *Kane Monument*

Also in section 5 is the John Kane Monument. Kane was a stonecutter who was working on the construction of the

Kane Monument.

Tennessee State Capitol at the time of his illness and death. His fellow stonecutters paid William Strickland to design a marker for him, and on the top of it is a stonecutter's work shelf, with his tools laid out. He has symbolically laid them down, never to return.

Rutledge Monument.

3. *RUTLEDGE MONUMENT*

In section 4 is the Rutledge family plot. Henry Middleton Rutledge was the son of one of South Carolina's signers of the Declaration of Independence, and his wife Septima Sexta Middleton Rutledge was the daughter of the other signer from South Carolina. They moved to Nashville and built Rose Hill, their family home on College Hill, part of which we saw in the first tour in this book. Henry was born in 1775 and died in 1844. Septima Sexta (which is Latin for seventy six) was born in 1783, and her proud father named her for the year of the Declaration's signing. She died in 1865.

HISTORIC CEMETERIES 155

4. GENERAL BUSHROD JOHNSON MONUMENT

General Bushrod Rust Johnson is buried alongside his wife in section 12. He was thrown out of the U.S. Army for financial improprieties during the Mexican War, and served as a military instructor at the Western Military Institute at the University of Nashville prior to the Civil War. He served as a Confederate general, which is ironic, as he had worked as a slave smuggler on the Underground Railroad in Indiana prior to his moving South. He was born in 1817 and died in 1880. His wife was born in 1825 and died in 1858.

Johnson Monument.

5. GENERAL WILLIAM CARROLL MONUMENT

General William Carroll served alongside Andrew Jackson in both the Creek War and at the Battle of New Orleans. He served as governor for twelve years and was the chairman of the Democratic Convention in 1844, which nominated Tennessean James K. Polk for president. In 1819, he brought the first steamboat to Nashville and had named it for his friend, the *General Jackson*. Carroll was born in 1788 and died in 1844.

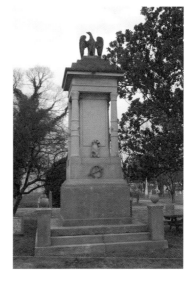

Carroll Monument.

6. LIEUTENANT GENERAL RICHARD STODDART EWELL MONUMENT

Lieutenant General Richard Stoddart Ewell of the Army of Northern Virginia is buried in section 28.2. He was born in 1817 and died within days of the death of his wife, in 1872. He

Ewell Monument.

had married Lizinka Campbell Brown following the war. She was born in St. Petersburg, Russia, when her father was serving there as U.S. minister to Russia. Her father had been a justice on the Tennessee Supreme Court and had sold the land his house stood on for the site of the Tennessee State Capitol. Theodore Roosevelt visited General Ewell at the general's farm in Spring Hill, Tennessee, while he was writing *The Winning of the West*.

7. JAMES AND CHARLOTTE ROBERTSON MONUMENTS

Robertson Monument.

General James Robertson and his wife Charlotte Reeves Robertson are buried in section 28.51. He was born in 1742 and died in 1814. She was born in 1751 and died in 1843. The Daughters of the American Revolution replaced their markers in 1927. The Robertsons were instrumental in the settlement of Middle Tennessee, so much so that he is referred to as the Father of Middle Tennessee.

8. CAPTAIN WILLIAM DRIVER MONUMENT

Captain William Driver is buried in section 20. Born in Salem, Massachusetts, in 1803, he died in Nashville in 1886. A ship's

HISTORIC CEMETERIES 157

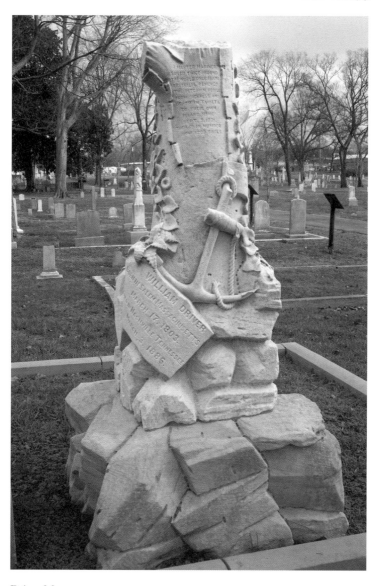

Driver Monument.

captain, he was given a flag for his first command, and he was so proud of his ship, his command and his country that he gave that flag a new name—Old Glory. He took Old Glory around the world twice, around Australia once, moved the *Bounty* mutineers from Tahiti back to Pitcairn Island and then settled here when his wife died in order to raise their children near his brother's family. An ardent Unionist, he hid Old Glory from his family and neighbors during the nine months that Nashville was within the Confederacy. When the city was conquered, he

removed it from the quilt he had hidden it in and it flew over the newly conquered Tennessee State Capitol. His sons had lived in Nashville long enough to absorb a local ethos, and served in the Confederate Rock City Guards from Nashville.

9. *General Felix Zollicoffer Monument*

Felix K. Zollicoffer, born 1812 and died 1862, is buried in section 20. He was a Whig newspaper editor prior to the Civil War, state adjutant general and comptroller, a state senator and a U.S. representative. When the Civil War began, he was made a general in the Confederate forces. His only prior military experience had been thirty years earlier in the Seminole War. He became the first Confederate general to die in the western theater of the war.

10. *Fisk Jubilee Singer Mabel Imes*

Mabel Lewis Imes is buried in section 30. She was born in 1858 and died in 1936. She was one of the original Fisk University Jubilee Singers.

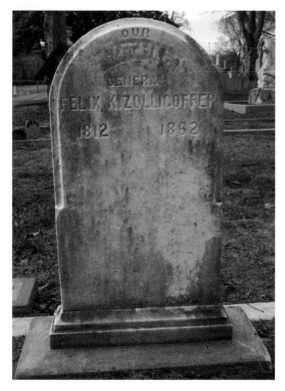

Zollicoffer Monument.

Historic Cemeteries

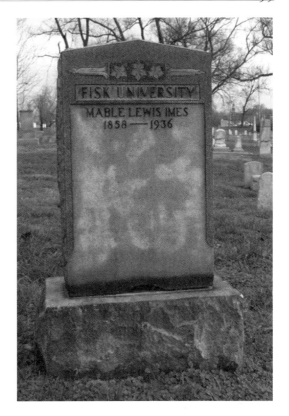

Imes Monument.

11. *Fisk Jubilee Singer Ella Sheppard*

Ella Sheppard Moore is buried in section 28.9. She was born in 1851 and died in 1914. She was also an original member of the Fisk University Jubilee Singers.

Mount Olivet Cemetery, 1101 Lebanon Road

Mount Olivet Cemetery was opened in 1856. It covers 250 acres and contains approximately 190,000 burials. It was the segregated burial place for white Protestants. Calvary would be developed

Sheppard Monument.

160 A Guide to Historic Nashville, Tennessee

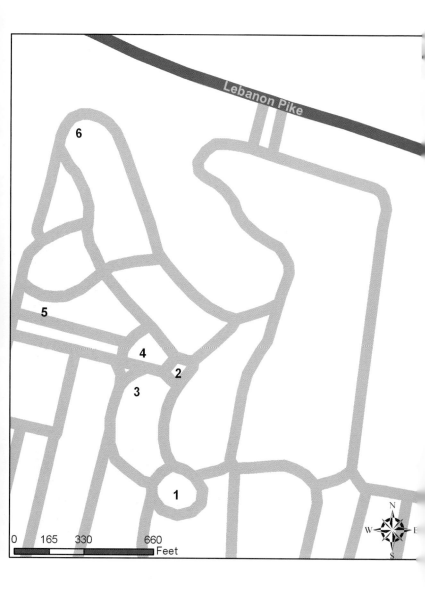

HISTORIC CEMETERIES

next door for Roman Catholics, Mount Ararat and Greenwood Cemeteries east and west of Mount Olivet would be segregated for African Americans and Temple Cemetery on Clay Street would be for Jewish people. Even in death, segregation was enforced.

1. CONFEDERATE CIRCLE AND THE ACKLEN FAMILY MAUSOLEUM

As you enter Mount Olivet, stop by the office building and pick up a map, and you might also wish to buy the guidebook. Go up the hill on the drive to the far left of the cemetery. At the top is Confederate Circle, in which 1,500 Confederate dead are buried. Behind the Confederate Monument is the mausoleum of the Acklen family. Adelicia Hayes married Isaac Franklin in 1839, and they had four children. He was twenty-eight years older than her. He died in 1846. She then married Joseph Alexander Smith Acklen in 1849. They had six children. All of the Franklin children died in childhood, and two of the Acklen children did as well. Joseph died during the Civil War. He had signed a prenuptial agreement, which afforded Adelicia sole

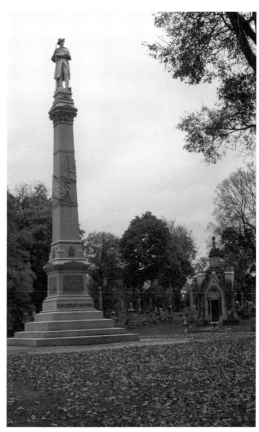

Confederate Circle and the Acklen Mausoleum.

control of the assets she had fought to win when she contested her first husband's will. It had stated that if she ever remarried, she would be disinherited. In 1867, she married Dr. William Archer Cheatham. In 1886, she sold Belmont, the family home, and moved to Washington, D.C. She died while on a shopping trip to New York City in 1887. She, her first two husbands and several of their children are buried here.

2. *DANIEL F. CARTER FAMILY MAUSOLEUM*

Continue up the drive to the next circle. The Daniel F. Carter Mausoleum is in the center of it, between sections 8 and 9. Designed in the Moorish Revival style, it was built to house the remains of John Carter, the son of Daniel and Mary Buntin Carter. He was killed at the Battle of Perryville in 1862. Daniel Carter lived from 1808 to 1874. He was a banker. When he refused to take the oath of allegiance to the United States after Nashville was conquered, he was arrested in his bank and imprisoned. His house stood on Sixth Avenue North across from the Hermitage Hotel location today. In 1864, General Grant seized his house as his quarters while he was in Nashville.

3. *V.K. STEVENSON MONUMENT*

In section 8 is the grave of Vernon King Stevenson (1812–1884). It is a black marble replica of Napoleon's tomb. Stevenson was a railroad promoter who brought railroads to Nashville, with

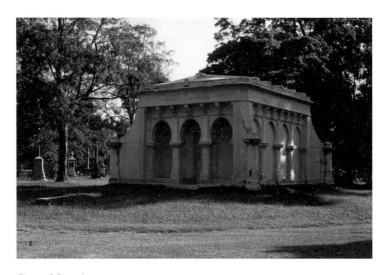

Carter Mausoleum.

HISTORIC CEMETERIES 163

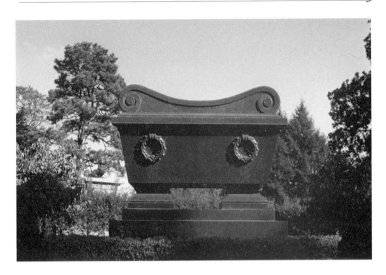

Stevenson Monument.

the formation of the Nashville and Chattanooga Railroad in 1854 as the first complete line to operate in the state. Stevenson, Alabama, was named for him. He fled Nashville prior to its fall and made money as a blockade runner during the war. After the war, he moved to New York City, and in 1880 sold out the Nashville, Chattanooga & St. Louis Railroad to the Louisville and Nashville Railroad.

4. THOMAS GREEN RYMAN TOMBSTONE

In section 9 is the grave of Thomas Green Ryman (1841–1904). Owner of the Ryman Line of river packet boats, he began earning money as a boy by selling fish to Union soldiers in Nashville. On one side of his tombstone is a small fishing boat denoting this, and on the other side is a steamboat, denoting his later work. He built the Union Gospel Tabernacle in 1892 for Revival meetings. At the time of his death, it was renamed the Ryman Auditorium.

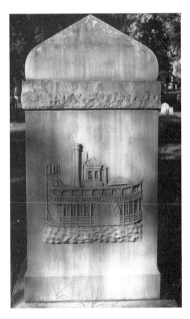

Ryman Tombstone.

5. *Francis Furman Monument*

Also located within section 9 is the Furman Monument. It was inspired by the Porch of the Maidens on the Erechtheum in Athens, Greece. Francis Furman was a merchant in Nashville, and his wife bequeathed to Vanderbilt University money with which to erect Furman Hall on the main campus in 1907.

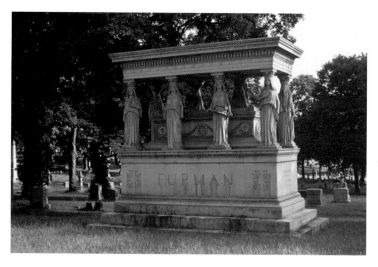

Furman Monument.

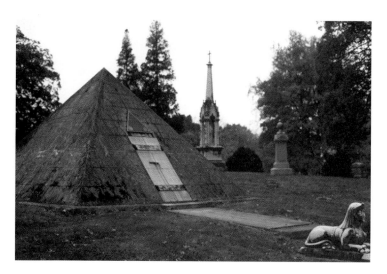

Lewis Monument.

6. *Major Eugene Castner Lewis Mausoleum*

In section 2 is the Egyptian pyramid guarded by a pair of female sphinxes, marking the resting place of Major Eugene Castner Lewis. He served as the director general of the Tennessee Centennial Exposition in 1897. He also served as the chief civil engineer for the Nashville, Chattanooga & St. Louis Railroad and pushed for the construction of Union Station. For the centennial, he was inspired to build a replica of Athens's Parthenon to serve as the art building for the fair and to have a statue of Mercury put up on the pediment at the Commerce Building. He later had Mercury moved to the top of the tower at Union Station. Unfortunately, it was blown from the tower in a storm in 1952 and was crushed by the force of its fall. A two-dimensional version replaced the original three-dimensional one in the 1990s.

Reading List

Brandau, Roberta Sewell, ed. *History of Homes and Gardens of Tennessee.* Nashville: The Garden Study Club of Nashville and The Parthenon Press, 1936.

Brumbaugh, Thomas B., ed. *Architecture of Middle Tennessee: The Historic American Building Survey.* Nashville: Vanderbilt University Press, 1974.

Bucy, Carole Stanford, and Carol Farrar Kaplan. *The Nashville City Cemetery: History Carved In Stone.* Nashville: The Nashville City Cemetery Association, 2000.

Clements, Paul. *A Past Remembered: A Collection of Antebellum Houses in Davidson County.* Nashville: Clearview Press, 1987.

Connelly, John Lawrence. *North Nashville and Germantown: Yesterday and Today.* Nashville: North High Association, Inc., 1982.

Graham, Eleanor, ed. *Nashville: A Short History and Selected Buildings.* Nashville: Historical Commission of Metropolitan Nashville–Davidson County, 1974.

Hall, Patricia, ed. *Designed For Worship: An Architectural Perspective of Sacred Places in Middle Tennessee.* Nashville: Nashville Public Television and The Booksmith Group, 2007.

Herndon, Joseph L. "Architects in Tennessee until 1930: A Dictionary." Master's thesis, Columbia University, 1975).

Hoobler, James A. *Cities Under The Gun: Images of Occupied Nashville and Chattanooga.* Hong Kong: Rutledge Hill Press, 1986.

———. *Nashville: From the Collection of Carl and Otto Giers*. Charleston: Arcadia Press, 1999.

———. *Nashville: From the Collection of Carl and Otto Giers, Vol. II*. Charleston: Arcadia Press, 2000.

Orr, Frank, Elbridge White and Charles Warterfield, eds. *Notable Nashville Architecture 1930–1980*. Nashville: Middle Tennessee Chapter, American Association of Architects, 1989.

Patrick, James. *Architecture in Tennessee, 1768–1897*. Knoxville: University of Tennessee Press, 1981.

Thornton, Lee Ann. *Victorian Memories: A Study of Second Avenue*. Nashville: Historic Nashville, Inc., 1977.

West, Carroll Van, ed. *The Tennessee Encyclopedia of History & Culture*. Nashville: Rutledge Hill Press & Tennessee Historical Society, 1998.

Wills, W. Ridley, II. *A Walking Tour of Mt. Olivet Cemetery*. Nashville: Mount Olivet Cemetery Company, Inc., 1993.